T0286756

PETERBOROUGH AT WORK

JUNE & VERNON BULL

AMBERLEY

First published 2022

Amberley Publishing
The Hill, Stroud
Gloucestershire, GL5 4EP

www.amberley-books.com

Copyright © June & Vernon Bull, 2022

The right of June & Vernon Bull to be identified as the
Authors of this work has been asserted in accordance
with the Copyrights, Designs and Patents Act 1988.

ISBN 978 1 3981 1005 2 (print)
ISBN 978 1 3981 1006 9 (ebook)

British Library Cataloguing in Publication Data.
A catalogue record for this book is available
from the British Library.

Typesetting by SJmagic DESIGN SERVICES, India.
Printed in the UK.

CONTENTS

Introduction	4
The Early Years	5
The Georgian Period	9
The Victorian Years	15
The Twentieth Century	45
Looking Ahead	82
Acknowledgements	96

INTRODUCTION

Peterborough's origins can be traced back to ancient settlements on dry land by the River Nene after the building of the medieval cathedral. Its main growth period started in the nineteenth century when it became a railway city and a major industrial centre. It was particularly known for brickmaking, and the London Brick Company's factory supplied bricks for the whole country, but other industries were also important, including prominent names such as Perkins Engines, Peter Brotherhood, Baker Perkins, etc. Other historic industries reflected Peterborough's location at the edge of the Fens, such as British Sugar Ltd and barge transporters along the waterways.

Today, light industry and services predominate, but the city remains one of the fastest-growing areas in the country. This book explores Peterborough's working life, along with its people and the industries that have characterised it through the ages.

THE EARLY YEARS

Neolithic man found rich soil, fertile pastures, and good waters with an abundance of ploughlands and woodlands between 4000 and 3000 BC when the area by the River Nene was first settled and farmed. There have been significant pottery finds dating from that era and its unusual style became known as 'Peterborough ware'.

The Iron Age saw major settlements. When the Romans arrived in AD 43 they took over control of the area and built various forts, particularly around what is now Thorpe Wood, Ferry Meadows, Longthorpe and Castor. In fact, when Queen Boudica's army won a decisive battle against the Romans in AD 61, they subsequently retreated to the fortress at Longthorpe.

When the Anglo-Saxons arrived they displaced the Romans, and it is to them that Peterborough owes much of its origins. King Penda ruled from AD 626 to 655, and his son Peada brought Christianity to the region. Peada founded a monastery at Peterborough in AD 655. At that time what we now call Peterborough was known as Medeshamstede. It was not long before the monastery's importance grew, becoming a mother house as Christianity expanded.

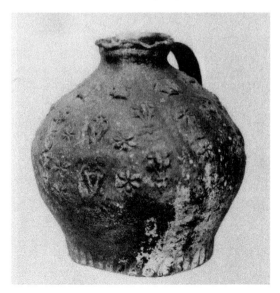

A pottery find, now in Peterborough Museum.

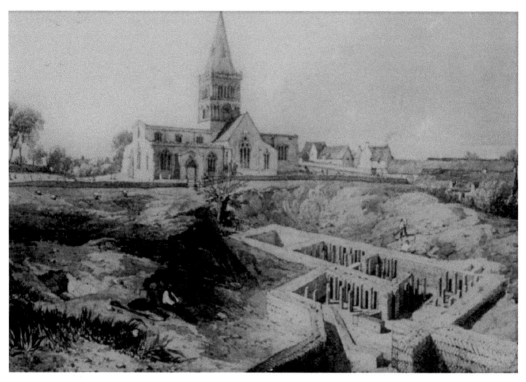

Drawing of Castor's Roman bathhouse.

The monastery was burnt down by the Danes, so a second church was built by King Eadgar. Peterborough was among the first resting places of Christianity in central England.

The Norman work of Peterborough Cathedral began in 1118 by John of Sais, and was only second in importance to Durham Cathedral. The choir was finished in 1143 and the nave around fifty years later; the west front was finished *c.* 1325. In 1883 the central tower was taken down and then rebuilt under the guidance of architect Sir Gilbert Scott. Among the many treasures of Peterborough Cathedral are the Saxon and Norman slabs and effigies, with the most noted being the Monk's (or Hedda) Stone.

There was not always harmony between local inhabitants and the abbey. During the Peasants' Revolt of 1381, when Richard II imposed a poll tax on the country (at that time still devastated by the Black Death), the Bishop of Norwich arrived with troops and brutally put down the riot. Hundreds were massacred on the Market Square (now Cathedral Square) and in St Thomas Becket Chapel (the site is now occupied by Starbucks).

The abbey's power came to a sudden end in 1539 when Henry VIII broke with the Roman Catholic Church and there was the subsequent Dissolution of the Monasteries. Instead of Peterborough Monastery being destroyed (probably because Henry's first wife, Catherine of Aragon, is buried there) it became a cathedral, with the town becoming a city despite having a population of just 1,500. The dean and chapter became lords of the manor of Peterborough and churchwardens took on the role of a modern local authority, as feoffees.

The cathedral was less fortunate during the English Civil War (1642–51), when Oliver Cromwell's Parliamentary forces ransacked it, damaging the interior and pillaging the cloisters. Charles I was captured and briefly held in the cathedral's gatehouse.

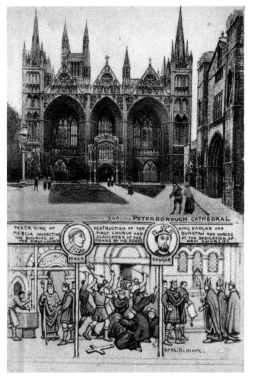

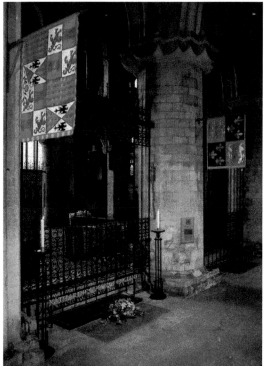

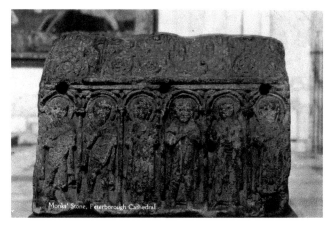

Above left: The first monastery and second church depicted in an old picture postcard.

Above right: Queen Catherine of Aragon's tomb in Peterborough Cathedral.

Right: Monk's Stone, Peterborough Cathedral.

In 1774 Peterborough was described as the smallest city in England, having fewer than 3,000 inhabitants. Its prosperity coming from the wool and cloth trade. The city also opened its first purpose-built theatre in 1774 (on the site where the Corn Exchange was later built, which is where St John's Square is today). Prosperity was not to last, however, as in 1786 the city had to petition Parliament for financial assistance due to the decline of the wool industry.

The Napoleonic Wars brought growth to the area, as in 1797 camps to house prisoners, enforced and otherwise, were built on a 15-hectare site at Norman Cross, close to Yaxley. It was the first purpose-built prison in the world and had a population of 10,000 – over three times that of Peterborough.

The skills of the inmates became famous as they made artefacts such as model ships and domino sets carved from wood and animal bone, a number of which can be seen at Peterborough Museum. Straw marquetry and other artworks were produced too. Some inmates were commissioned to make special items, with their patrons supplying extra materials where needed. Throughout their incarceration some prisoners had earned as much as 100 guineas – approximately £64,000 today.

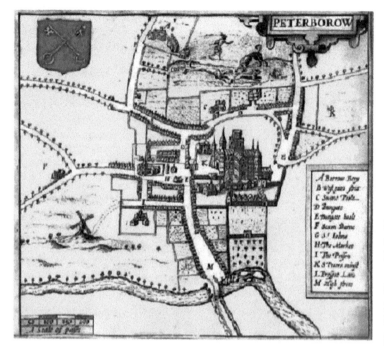

Left: A Seventeenth-century map of Peterborough.

Below: An antique print of the Norman Cross prison camp.

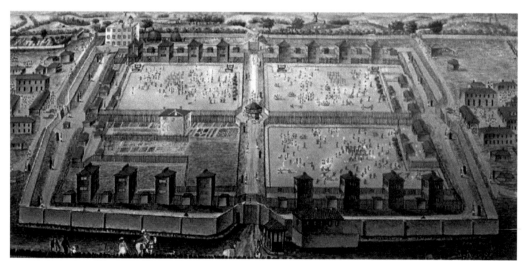

THE GEORGIAN PERIOD

The Napoleonic Wars bring us neatly into the Georgian period (1714–1837), which is rather forgotten in Peterborough's history. The Industrial Revolution and the fascination with machinery really bloomed during this era. Several buildings located in the cathedral precincts, Priestgate, Thorpe Road and elsewhere are really noteworthy, and still exist.

The Georgian period was a time of gracious living for the wealthy in Peterborough. There was cockfighting at the Angel Inn and horse racing on the Common (now Fengate). The town had its very own champion jockey, Francis 'Frank' Buckle (1767–1832), known as 'the Pocket Hercules' and weighing only 3 stone 13 pounds, who lived on his farm at Botolph in Orton Longueville (now the Botolph Arms). Frank's championship record was not beaten until the arrival of Lester Piggott, who won his first race in 1954.

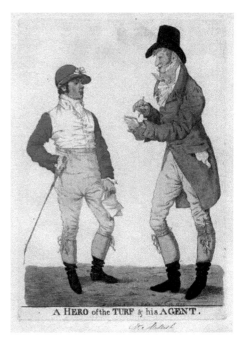

A HERO of the TURF & his AGENT.

Francis Buckle (left) and his agent, Henry Francis Mellish.

For the less wealthy, the pastime of gambling and drinking plus bull-running in the Market Place (now Cathedral Square) was also a well-attended frivolity. Other high jinks included theatre-going, where audiences could be rude, noisy and dangerous. Alcohol and food were consumed in large quantities and people arrived and left throughout the performance.

Other forms of entertainment included executions, which took place on Lincoln Road at the junction of Burghley Road, formerly Lincoln Road East, and the Millfield end of Lincoln Road before moving to Fengate. The last of these executions – a public hanging – was in 1813. These events would be regarded as a pleasurable day's outing for the masses.

Georgian glassware and pottery are all part of the treasures at the city's museum, located on Priestgate, which itself is a mainly a Georgian building. Its oldest parts date back to the sixteenth century, but most of what you see today was opened in 1816 as the grand house of Thomas Cook, a city magistrate.

The year 1816 also saw the foundation of modern medical provision in the city, thanks to some money left by the local yeomanry cavalry. Local gentry raised a cavalry unit to defend the area against Napoleon in the event of an invasion. At the end of the war, they had a huge amount of money left and decided to donate it to provide medical treatment for those in Peterborough who could not afford it. Thus, the People's Dispensary was established.

Local Napoleonic prisoners made automata, little mechanical toys, because machines became fascinating to people. This fascinated people and increased their curiosity with regard to mechanisation.

Many local people became famed for their achievements or lifestyle. One such example of the latter was the city's MP, Sir Edward Wortley Montagu, generally known as 'Mr Wortley', who was married to Lady Mary (née Pierrepoint) and was our political representative for south of the river from 1734 to 1747 and 1754 to 1761. He donated Wortley's Workhouse, later known as Westgate Almshouses, to the poor of the parish of St John the Baptist, Peterborough Parish Church.

It is believed that Edward was appointed ambassador to Turkey on 7 April 1716 to negotiate between the Ottoman (Turkish) Empire and the Habsburg (German) Empire because his wife, Lady Mary, was having an affair with George I.

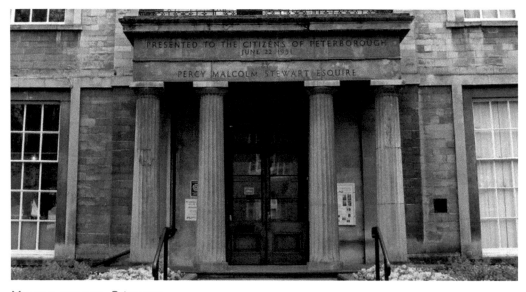

Museum entrance, Priestgate.

Above: Westgate almshouses.

Right: Etching of Lady Mary Wortley Montagu.

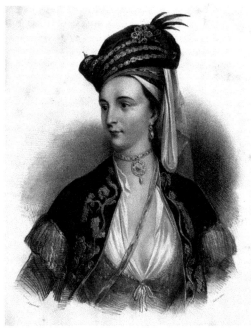

Lady Mary is best remembered as a writer and diarist (her posthumously published *Embassy Letters* describing her early experience in Constantinople became a huge bestseller), and for bringing the Ottoman practice of inoculation against smallpox (known as variolation) back to England. In Asia, practitioners developed the variolation technique of deliberate infection with smallpox. Dried smallpox scabs were blown into the nose of an individual who then contracted a mild form of the disease. Upon recovery, the individual was immune to smallpox. Between 1 and 2 per cent of those variolated died, as compared to 30 per cent that died when they contracted the disease naturally. In the 1790s Edward Jenner developed a safer method – vaccination.

Other notable people associated with Georgian Peterborough include the poet John Clare; Dr John Hill, physician, playwright, author and botanist; Fenwick Skrimshire, physician and naturalist; Charles Mordaunt, 3rd Earl of Peterborough and 1st Earl of Monmouth, military leader and diplomat; Matthew Wyldbore, Whig MP for Peterborough; and Thomas Worlidge, painter and etcher (known at Britain's Rembrandt).

Perhaps one of the most well-known local men during the early part of Georgian Peterborough was Henry Penn (d. 1729), who cast more than 250 bells at his Bridge Street foundry, which was on the site of what is now Peterborough Magistrates' Court. Back then a canal named Bell Dyke ran behind the foundry before joining the River Nene. Most of Penn's bronze bells were transported on barges; they went to over 100 churches, schools and homes across England.

Twenty years before his death he cast the first of ten bells for Peterborough Cathedral. The largest of these weighed 1½ tons and is named the City Bell. The latter strikes out the time on the cathedral clock. Other bells from the ten cast by Penn in 1709 have since found their way to America. The last surviving cathedral bells cast by him were replaced in 1987.

It is thought that Penn moved to Peterborough in 1708/09 to a row of houses named Rotten Row (on the east of Bridge Street), owned by his wife's family – the Shepherds. It was here that he established his foundry. As a master bellfounder, Henry Penn was able to start his new business because he knew there was enough work in the town and its surrounds, and because he had the right location of premises, as well as the means of transport for it to succeed. Penn was able to take on enough work and it is said that he put the nearest bellfounder – the Norris family of Stamford – out of business. The latter cast some of the bells for Peterborough's parish church, St John the Baptist Church on Cathedral Square. Henry and his wife Diana had their eight children baptised there.

Penn quickly realised that there were many old bells that could be recast and thus there was little need for the tin and copper to be mixed in the foundry to make bronze. He was said to be rugged and hard-working, and many deals were made with the shake or clasp of hands, or by a gentleman's agreement. He would travel far and stay overnight to clinch a deal, but always having done his homework first. Penn would always inquire at the local hostelry where the churchwardens lived before visiting the church and chatting to the vicar to secure a sale. He totally understood that churchwardens would be happy to have their names cast on the church bells so that their names would live on. He certainly appears to have been very savvy about his customers and their requirements. These attributes made him a great salesman.

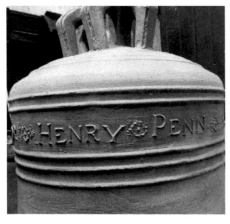

Bell cast by Henry Penn.

Baptismal font and war memorial in St John's Church.

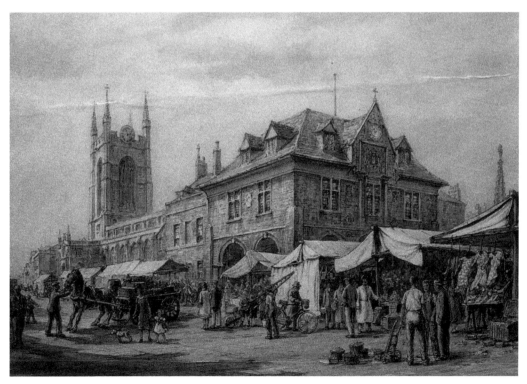

St John's Church from the Market Place.

Penn, ever the self-employed entrepreneur, seems to have ventured into the medical world, as in the few years from 1715 onwards he started to make a frame for people that had ruptured discs in their spine. These trusses were made of metal plate and held in position with leather straps.

Today Henry Penn is remembered by way of a sculpture erected close to his foundry titled *Voice of the City*. It was unveiled on 20 December 2017 at Lower Bridge Street and depicts the stages of a bell being cast. The 5-metre-high sculpture was created by artist Stephen Broadbent. In Penn's honour the walkway between Bridge Street and the Riverside car park has been renamed 'Foundry Walk'. Additionally, the sculpture is sited a few meters away from Henry Penn Walk, which runs near Rivergate and along the River Nene.

If you would like to read more about what this area was like in the Georgian period, then Lord Orford's voyage around the Fens from the 1770s is a good read. George Walpole, 3rd Earl of Orford, and his friends were so filthy rich that they spent money like water. Lord Orford visited Peterborough twice: to attend the horse racing at Flag Fen and to have dinner with Bishop John Hinchcliffe at the Bishop's Palace.

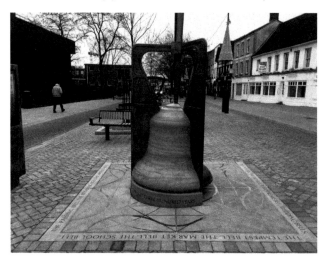

Henry Penn sculpture *Voices of the City*.

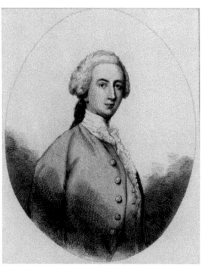

Rt Hon. George Walpole, 3rd Earl of Orford.

THE VICTORIAN YEARS

The coming of the railways was the next major boost for the city. The first railway line reached Peterborough from Northampton in 1845. Next came the direct Great Northern Railway (GNR) route to London, followed in 1850 by what became the East Coast Main Line to Scotland. Suddenly Peterborough became a major railway town and home to engineering workshops. Many other industries followed, and we explore some of them here.

By 1861 the railways were employing 2,000 people and the population had increased to 11,732. Thus, 17 per cent of those of working age worked for the railways – almost one in five.

With the Victorian expansion came bustling industries, and Peterborough soon developed into an industrial complex. So great was Peterborough's intensive development that in 1874 it became a municipal borough with a council to run its services. This administration gave us piped water and sewers, plus more housing to accommodate the burgeoning workforce.

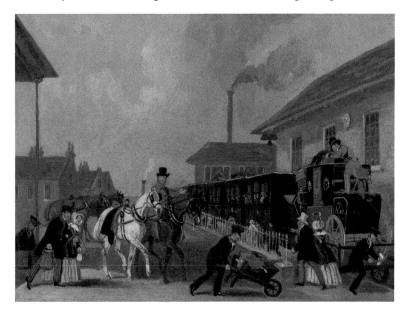

Peterborough's first railway.

BRICKMAKING

The railway boom helped encourage the local brickmaking industry and, as the population increased from 17,429 in 1871 to 30,000 in 1898, it meant that more workers were attracted to settling in the city. Hand-crafted brickmaking came to the area in the eighteenth century, but only on a small scale, with yards scattered across the locality.

The origins of the London Brick Company (LBC) rests with John Cathles Hill, a developer-architect born in Dundee in 1857, who built houses in both London and Peterborough. In 1889, Hill bought the small T. W. Hardy & Sons brickyard at Fletton, and it was this business that was incorporated in 1900 as LBC. The generic name 'Fletton' is given to bricks made from lower Oxford clay, giving them a low fuel cost due to the clay's carbonaceous content. Fletton bricks under LBC manufacture were trademarked as 'Phorpres'.

Clearly, in the construction of Phorpres House, at No. 189 London Road, John Hill wanted to show the many splendid bricks available from his yards to good effect.

Presses capable of making 3,000 bricks in 10 hours were available in 1911. The modern LBC derived its name from supplying London with its increasing demands for housing. Peterborough soon became the centre of British brick manufacturing – dominated by LBC. The railway was crucial to the company, but transportation soon changed in the 1930s when LBC built up a fleet of delivery lorries.

In 1912 the business ran into financial difficulties and a receiver was appointed to run LBC. John Hill died in London on 5 April 1915, but after the receiver was discharged in 1919 Hill's son continued to run the company.

An unsuccessful application for an alcohol licence was made in respect of the Phorpres House in 1899 and it became known as the 'Coffee Palace'. The building was sold to Peerless

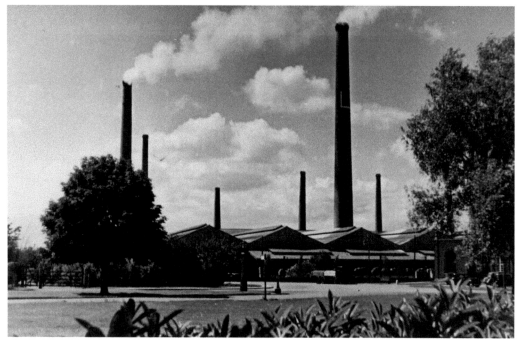

London Road brickyards.

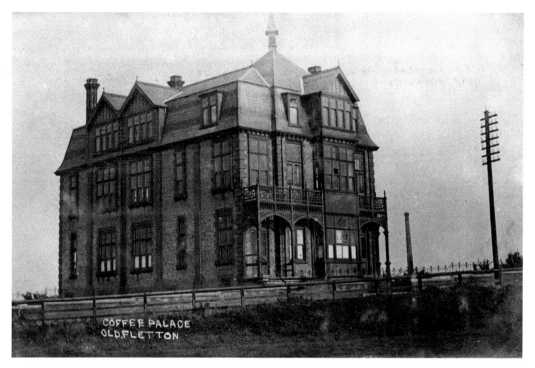

Coffee Palace.

Foods (a pastry mouldings manufacturer) in 1917 and used as their offices and a goods depot. In 1928 the property was repurchased by the London Brick Company and named Phorpres House, with it being used as their district office.

The Second World War boosted LBC's brick demands for shelters and repairs during the Blitz, making the railways even busier.

Eventually LBC was bought out by Hanson PLC in 1984. Hanson divested most of its interests and the company is now known as Forterra. Since 1988 Phorpres House has been in residential use as privately owned leasehold flats. Brickmaking continues in the area to this day.

SOME BYGONE SMALL- AND MEDIUM-SIZED BUSINESSES

At the turn of the last century Peterborough was described as the cathedral city on the Nene, the gateway to the Fens, and favourably known as the last stop of many London express trains.

At the heart of our city centre was the Market Place (now Cathedral Square) and one of the high-class businesses located there was H. B. Vergette, General Furnishings and Agricultural Ironmongers, as well as it being a parcel-receiving office for electric trams. The business was established in 1829 by George Vergette and it was a leading local company. George Vergette was succeeded by his nephew, Francis, in 1874.

Vergette also owned a large market garden with eight greenhouses in Wellington Street. The business in Market Place sold saws and all kinds of tools, trunks and tinware, cooking ranges and household brass and iron fittings, as well as agricultural implements. Large stocks

FRANCIS VERGETTE,

PETERBOROUGH,

WHOLESALE & RETAIL

FURNISHING, AGRICULTURAL, & BUILDERS'

IRONMONGER,

STEEL & BAR IRON MERCHANT,

Manufacturer of Agricultural Implements, Wrought Iron Work of every description, and Special Implements and Machinery.

CHURCHES, PUBLIC BUILDINGS, GREENHOUSES, &c., HEATED.

BELL-HANGING AND GAS-FITTING, &c.

Experienced Workmen kept for Repairing and Fixing all kinds of Implements and Machinery.

ESTIMATES GIVEN.

A large Stock of the most approved Agricultural and Horticultural Implements and Domestic Machinery of every description, sold at Makers' Prices.

Vergette, ironmongers.

were kept in the storerooms of the premises and workshops extended far to the rear and filled the upstairs floors.

At No. 50 Cowgate was Charles S. Julyan – a high-class boot and shoe dealer. The premises used to be the Blue Bell Inn, but with the reduction in licences the pub closed and was specially adapted by Mr Julyan. The double-fronted shop exhibited a choice of footwear for ladies, gentlemen and children. Favourite brands sold at the time included Dorothy Vernon and Emilyn for ladies and Wardwycke black and tan shoes for gents. Boot and shoe repairs were also undertaken. Mr Charles Julyan was sub-captain of the Peterborough Cycling Club.

John Thompson & Co., builders and contractors, had offices and works in Wood Street (between Cowgate and Westgate) and for generations were entrusted as important commissions in the repairs of cathedrals and the erection of some of the best-known buildings in England. Employing 550 people in the early 1880s, they were one of the largest local employers in Peterborough. The first John Thompson was succeeded by his son, Alderman John Thompson JP (four times Mayor of Peterborough). When he died in 1898 the business was taken over by his sons, Mr T. J. Thompson and Mr W. S. Thompson, and they partnered with Mr Walter Hill, who died in 1909.

The work of the firm included the taking down and re-erection of Peterborough Cathedral's great central tower and repairing its western front. Hereford, Chester, Litchfield, Bangor, Salisbury, Llandaff, Asaph, Lincoln, Dublin, Armagh, Ripon, Southwark and Winchester cathedrals also bear witness to the work of this famous firm. They were appointed contractors to Edward VII in 1905 and undertook extensive alterations work at Sandringham. The royal warrant was renewed by George V.

John Thompson & Co. were the builders of the King's School, Peterborough, and they also erected Glasgow University buildings, Selwyn College (Cambridge), the Royal College of Music, the Royal Holloway College at Egham (at a cost of £300,000) and many other public and semi-public and private works, such as at Hever Castle.

Mr T. J. Thompson was elected a city councillor in 1905 and, along with his brother Mr W. S. Thompson, was an active member of the Conservative and Unionist Party. The firm undertook the erection of the Conservative Club in Park Road at cost price only.

Moving away from construction, Mrs J. F Ives, a beauty specialist, could be located at Rothesay Villas, No. 65 Lincoln Road. She was an accomplished lady who had travelled widely to other parts of the world to learn various beauty treatments and the secrets of

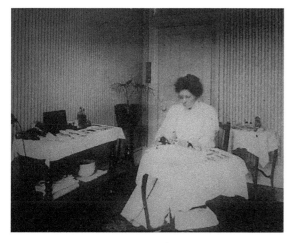

Above: Mrs Ives Beauty Specialist, No. 65 Lincoln Road.

Right: No. 65 Lincoln Road.

her trade. At the turn of the last century not many beauticians could be found outside of London, so Peterborough is to be congratulated on having a fully qualified professional in its midst at this time.

Mrs Ives continued to visit her patrons in Eaton Square, London, every Monday. As a beauty specialist she concentrated on the head, face, hands and feet, using the latest treatments. Mrs Ives is said to have received numerous expressions of satisfaction from her many customers. It is interesting to note that she charged local customers at lower prices than her London ones – considering it was a fairly new venture, the results were incredibly positive – many Peterborough ladies were said to be extremely pleased about that!

BARFORD AND PERKINS

Barford and Perkins made petrol rollers based on their well-established range of horse-drawn rollers. The company was formed when Amies and Barford ceased trading and the Queen Street ironworks was bought on 18 October 1871 by William Barford and Thomas Perkins for £2,000. Five years later they were an exhibitor at the Royal Agricultural Show at Birmingham with their ploughing tackle.

In 1888 they started to produce the water ballast steam roller. In 1904 they introduced petrol and paraffin rollers into their product range. From 1913 to 1917 they produced paraffin motors for commercial and agricultural purposes, including tractors, ploughs, sprayers, etc.

They undertook munitions work throughout the First World War – mainly engaged on shells principally. In 1920 they showed how to apply the internal combustion engine to road rollers at the Darlington Agricultural Show, and in that same year they became part of Agricultural and General Engineers Ltd. By 1927 Barford and Perkins introduced diesel rollers and seven years later they merged with Aveling and Porter to become Aveling-Barford.

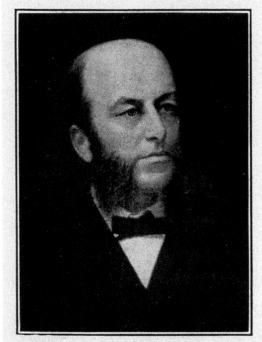

WILLIAM BARFORD, 1832–1898

Left: William Barford.

Below: Barford & Perkins workers.

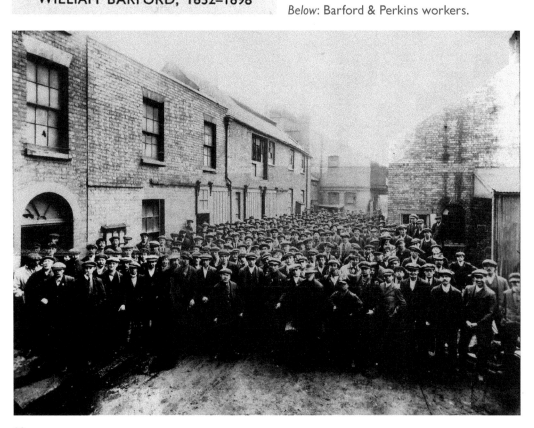

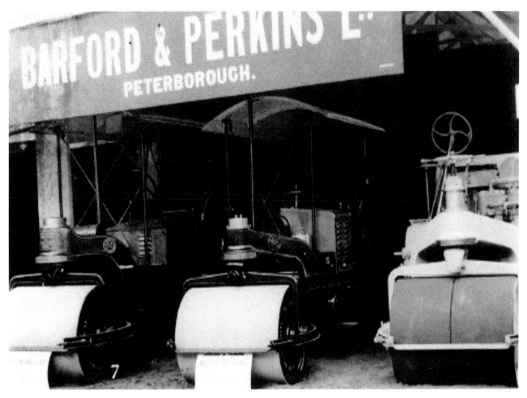

Above: Fleet of Barford & Perkins motor rollers.

Below left: Barford & Perkins motor roller.

Below right: First World War memorial, Barford & Perkins Queen Street ironworks.

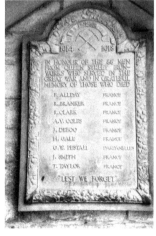

A memorial to the men from Queen Street ironworks who lost their lives in the First World War can be seen outside St John the Baptist Church's north porch entrance, opposite Queensgate shopping centre.

J. P. HALL & SONS

This company was established in Peterborough in 1899 by John Percy Hall. Their factory was situated off London Road and they manufactured direct-acting pumps of Hall's own design.

From small beginnings the company made a name for itself in the manufacture of marine and electric lighting station pumps for boiler feeding, and also oil pumps for innumerable purposes.

During the First World War they were under government control on submarine work, tank parts and battleship accessories.

The workforce of over 100 were said to be fiercely patriotic after the sinking of the *Lusitania* in 1915 when it was torpedoed and sunk by a German U-boat, causing the deaths of nearly 2,000 passengers and crew. Thus, it is perhaps not surprising that management and employees took the severe loss of lives on the ocean liner to heart. The firm was contracted by the Admiralty to manufacture submarine pumps and battleship accessories to win the war at sea.

John Hall died at the age of seventy at his home at Sydenham, London, in January 1917. He was one of the first members of the North East Coast Institute of Engineers and Shipbuilders. On his death his son took over the business.

After the Second World War they specialised in equipment for oil tankers and oil refineries and its machinery was exported all over the world.

In 1962 W. H. Allen & Co. acquired the shares in J. P. Hall & Sons, and in 1963 there was a fall in demand for Hall's products, so the business amalgamated with W. H. Allen's Pershore division.

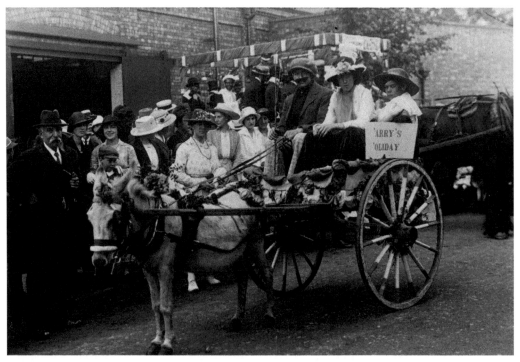

John Percy Hall (left).

 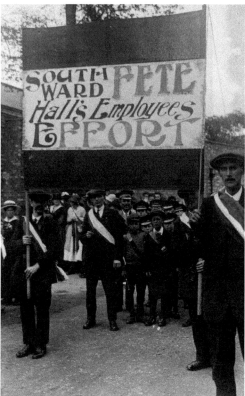

Above left: J. P. Hall workers on First World War service.

Above right: J. P. Hall workers fundraising for the war effort.

LUKE TURNER & CO. LTD

This business was started in 1857 when Luke Turner opened a factory at Leicester to produce elastic web. A few years later the Bishop of Peterborough, William Magee, was discussing with Mr Turner the lack of opportunities for girls in Peterborough, and as a result the first part of a new factory (built in 1877) was formerly opened in Princess Street, Peterborough, in 1878.

This textile and clothing manufacturer was viewed by most local girls and women to be very paternalistic, and many preferred this machine work over going into domestic service.

The results of building a second factory proved highly beneficial as extensions were made in 1908, 1912, 1915 and 1922, whereby the works covered a large area from Princess Street through to Huntly Grove.

One further development was the weaving of glass yarn into tapes for insulation, making them one of the largest producers of this kind in the country.

During both wars they manufactured webbing, used in the making of parachutes and some military uniforms and kit bags. They also made glider elastic launching ropes, shock absorber cords and rings.

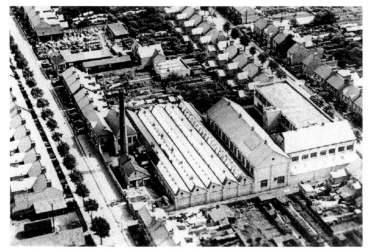

Luke Turner factory, *c.* 1940.

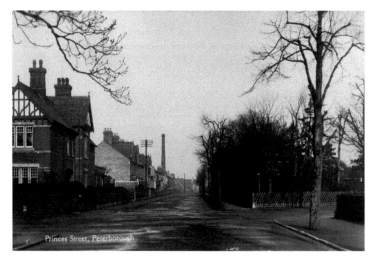

Luke Turner & Co. factory's chimney, visible from the junction of Park Road.

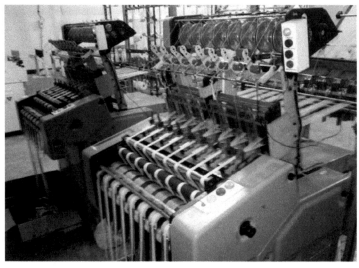

Luke Turner 1960s high-speed braiding machine.

In 1941 the company was taken over by Penn Elastics, an American-owned firm that merged with Clucksam and Kemp in 1966 when the Peterborough factory closed.

By 1960 the company had some of the most modern weaving and winding machines in the world and they produced every type of web, from wide to narrow for all kinds of trade.

The factory in Princess Street was only partly demolished after Luke Turner ceased trading and in 1967 it became the temporary home of Braidex before they moved to Fengate.

HENRY ROYCE OF ROLLS-ROYCE – A MAN WITH A PASSION

Most people know about Henry Royce's motor and aero-engineering achievements, but many are unaware of the man. Frederick Henry Royce was born the youngest of five children to James and Mary Royce (née King) at Alwalton Mill on 27 March 1863. Frederick preferred to be called Henry and was just twelve years old when his father, a failed flour miller, died. Henry, who lived by the motto 'Whatever is rightly done, however humble, is noble', had to go out to work selling newspapers and delivering telegrams to support his widowed mother and four siblings.

In 1906 Rolls-Royce Limited was formed, but it is interesting to note that Royce and Company remained a separate business, making cranes until 1932, when it was bought out by Herbert Morris of Loughborough. The last Royce-designed crane was built in 1964.

Sadly, the personal partnership of Rolls-Royce ended when Charles Rolls was killed in an air crash in 1910. Further sadness came about for Henry when he and his wife, Minnie (Marion), separated in 1912. When Henry was ill with stomach cancer he was looked after by a nurse named Ethel Aubin. It is said that his propensity for working to incredibly tight deadlines for his entire life resulted in him hardly setting aside time to eat properly, and that he was plagued throughout his lifetime with intestinal problems.

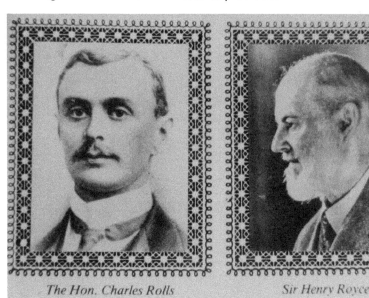

The Hon. Charles Rolls *Sir Henry Royce*

Sir Henry Royce and Charles Rolls.

Following the success in the motor industry, the company branched into aero engines in 1914 to meet the need in Britain for air power for the First World War, before moving into civil aviation.

On 26 June 1930 Henry Royce was created a Baronet of Seaton, Rutland, for his services to British aerospace (designer of the 'R' aircraft engine).

Henry Royce, motor car and aeroplane designer, died at the age of seventy at his house, Elmstead, West Wittering, near Chichester, on 22 April 1933. In 1937 Henry's ashes were interred in Alwalton Church. To this day Henry Royce is acknowledged as one of Britain's foremost engineers.

Today Rolls-Royce is owned by BMW and is based in Goodwood, Sussex. Two per cent of the UK's total goods exports are from Rolls-Royce. Among their defence products are fighter jet engines, helicopter engines and unmanned aerial vehicles.

Henry gained great wealth from lowly beginnings. He owned many great houses in Britain and abroad. Henry designed La Villa Mimosa in 1912, overlooking the Mediterranean, at Le Canadel (off the D559 road) in southern France, and it was built a year later. The house is in a very central location so all the main towns – such as Nice, Monte Carlo, Marseille and St Tropez – are a short drive away and easily reached.

Villa Mimosa can accommodate twelve people as it has six bedrooms (two downstairs and four upstairs, with four of the bedrooms having sea views) and three bathrooms. The garden is private, with ample parking. It is a big, bright and airy house, quite beautiful but not in any way fussy – just like its designer.

Alwalton Church.

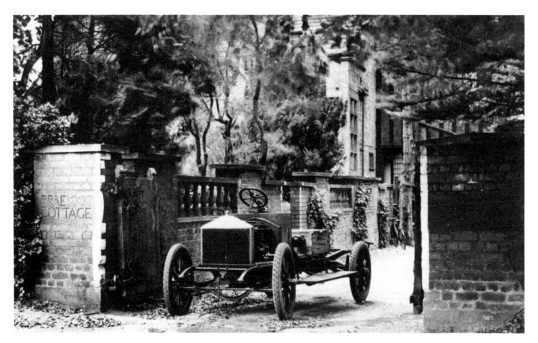

Above: The first prototype Royce car, Brae Cottage, Knutsford – Royce lived here for ten years.

Right: Royce's six-bedroom villa, La Villa Mimosa, in Rayol-Canadel-sur-Mer, southern France.

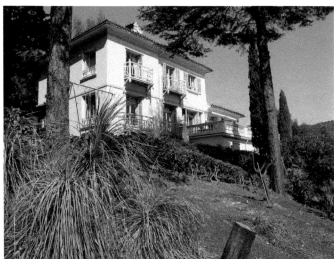

EBENEEZER SELLERS

Sellers Basket Works, Wharf Road, Woodston, was a profitable business in the mid- to late Victorian period. The business was started by Ebenezer Sellers, who was born in 1846 at the toll house on London Road (junction of Oundle Road) where his father, Joseph, was the toll gatekeeper, as well as running his small basketmaking business.

Ebenezer served his apprenticeship with his father's basket business and soon became the senior partner. Sellers Jr grew his own osiers (willows) when he purchased the lease

from the Marquis of Huntly on 25 March 1874 for the existing 44 acres of osier beds from Woodston to Botolph Bridge and Orton Longueville. The willows were brought downriver by barge and the last few yards were transported by donkey. Most of these willow fields/beds disappeared when the British Sugar Beet factory was erected in 1926.

Sellers were known for their wicker and splint basketry making, using willows and reeds to make hampers predominately, but also shopping baskets, confectionary trays and baker's baskets, etc.

The osier peelers used a metal tool to remove bark from willow rods or osiers, which were used in basket weaving, and this work was usually performed by women and children. They were also known as withy peelers.

The basketmaking business started to boom when Ebenezer won government contracts at home and abroad from railway companies and the General Post Office. Other customers included agricultural workers, the military in India and the British army, Smithfield market and the domestic market for linen baskets.

By all accounts Ebenezer was a shrewd businessman and patented a design for a Post Office hamper during the 1890s, which brought in so many orders that he had to employ an additional sixty people at his Woodston works. The growth in basketmaking meant he had to purchase 10 tons of osiers (willows) annually from the Corporation Farm at Fengate to top up the quantity needed for the number of orders gained.

Sadly, the firm suffered a major fire in April 1922. However, this was not to be the last of their woes because as time went by the business was affected by substantial changes in the way the Post Office and other markets progressed. For example, the Post Office stopped buying hampers because they started to send parcels in bags (just like their letters), plus the railway also stopped buying wicker hampers to transport meat and poultry and other perishable goods. The latter was rendered unnecessary as refrigerated vans were being introduced and this was considered much more hygienic with even-temperature control. Thus, Sellers Basket Works witnessed a huge decline in orders, with only pigeon fanciers, fruit growers and laundry companies keeping the basket trade viable into the 1930s.

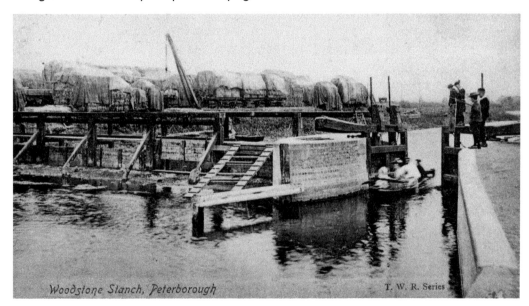

Woodstone Stanch, Peterborough T. W. R. Series

Woodston Staunch.

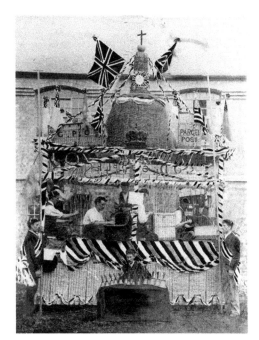

Right: Sellers coronation float to celebrate George V, 22 June 1911.

Below: Sellers baskets at GNR station.

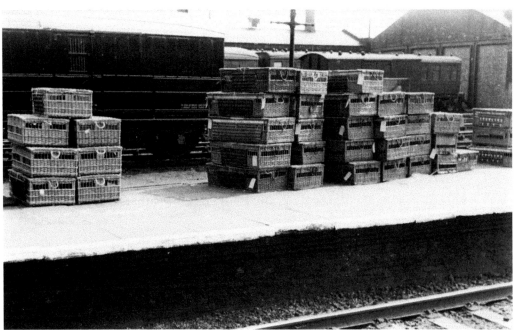

Ebenezer's son, Joseph, took over the company at the end of the First World War and continued in business until 1932. After Sellers Basket Works closed the building was used as a warehouse. It still stands today at the bottom of Wharf Road, but is occupied by Complete Framing Ltd – part of the commercial units on the Wharf Industrial Estate. Another acknowledgement to Sellers Basket Works' is the nearby Ebenezer's Social Club in Grove Street, Woodston.

RUNNING ON THE RAILS – OUR TRAM STORY

Public wheeled transport had been in the city from the late 1850s as the GNR established rail works in New England, and wagonettes were used between New England and the Market Place on market days and at weekends. Horse-drawn trams and tramline routes were discussed at a council meeting in 1880 but were never begun.

In 1896 horse-drawn omnibuses were introduced and the Peterborough Omnibus Company worked on routes between Long Causeway, Werrington, New England, Woodston, Fletton, Stanground, Farcet and Longthorpe. Stabling was in Evan's Yard, off St John's Street. Each bus had eight horses for a day's work, with the pairs changing every 2 hours.

The British Electric Traction (BET) Company Ltd (the largest group in Britain) applied to the Light Railway Commissioners to run light railways in the soke of Peterborough, city of Peterborough, and in Woodston.

In 1899 powers were granted for tramlines to Walton, Dogsthorpe, Newark, Woodston and Stanground, but a line to Stanground and a circular route to Woodston were refused because Narrow Bridge Street was too narrow, as its name suggests, and because of difficulties in crossing the Great Eastern Railway line on the same level. Construction of the tramway began on 12 May 1902 by contractor J. G. White & Company Ltd. The track was 3 feet 6 inches wide and was laid as a single line with passing places to take two tramcars.

Peterborough's electric tramway system was a comparatively small one, with a maximum of fourteen cars and a track-watering car, which could also be used as a snow plough.

In autumn 1902, the local press was invited to view the first tramcar at the BET Company depot on Lincoln Road. The 3-foot 6-inch-gauge overhead wire system opened on 24 January 1903 between Walton and Long Causeway, with a route to Dogsthorpe following a week

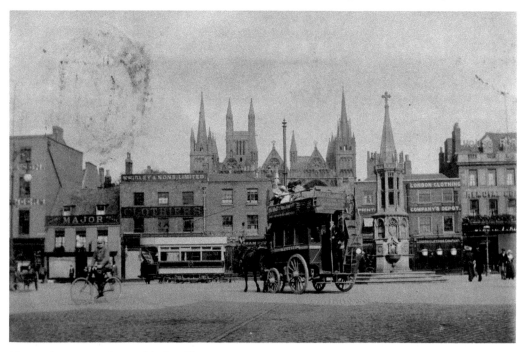

Horse-drawn omnibus at Market Place.

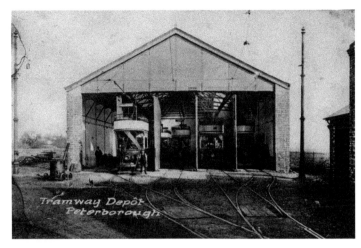

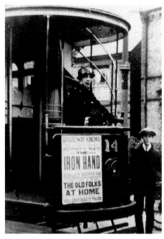

Above left: Tram depot, Lincoln Road.

Above right: Henrietta Smith of No. 35 Eastgate was the city's first lady tram driver.

later. Newark was reached on 28 March 1903, with a total route length of 5 miles. The depot and offices were built in Lincoln Road at a cost of £3,000. The depot comprised of five roads that converged to a single-line junction in Lincoln Road, facing the city. The points themselves were unusual in that they were changed by railway type point levers. The cars were all open topped and supplied by BET of Loughborough and equipped with two motors, each with 17 hp to cover the city's level terrain. The first twelve tramcars seated twenty-two passengers inside and twenty-six outside (on the top deck) on traversable wooden garden-type seats. Cars 14 and 15 (there was no number 13) were acquired in 1905 and could accommodate twenty-eight on top. The tramcar livery was brown and cream.

During the First World War women and temporary drivers were recruited, as in other towns and cities. During the General Strike of 1926 the trams stopped completely. In 1930 BET Co. Ltd approached the city council to abandon the trams altogether. The last tram to run was on 15 November 1930, with ten passengers. Double-decker buses took over the various routes.

In the twenty-seven years of service the trams travelled 6–7 million miles and carried over 50 million passengers. By the early 1970s all traces of tram standards had gone and the depot in Lincoln Road became a bus depot.

The local press reported the demise of the city trams as: 'Our famous trams are no more. They came heralded by the whole populace. They went unhonoured and unsung.' And: 'The trams have all gone to the Big Depot in the Sky.'

It is interesting that in more modern times there has been a real resurgence of trams in various cities and towns because of their economy and environmental friendliness.

HORSE BREEDERS AND TRADERS

Thomas and Elizabeth Nutt were local horse dealers and businesspeople. Thomas was born in Uppingham in 1850 and married Elizabeth Henson (aged twenty) in 1875 at Crowland Abbey.

The census of 1881 shows Thomas and Elizabeth Nutt living at No. 8 Double Row, Boongate (now Eastgate). The entry is as follows:

Thomas NUTT, head, aged 29, Horse Dealer, born Uppingham
Elizabeth Rebecca NUTT, wife aged 26, born Crowland
William Robert NUTT, son aged 5, born Peterborough
George NUTT, son aged 4, born Peterborough
Thomas NUTT, son aged 2, born Peterborough
Harry Henson NUTT, son aged 9 months, born Peterborough died 1881
Joseph BURTON, visitor, aged 30, Horse Dealer, born Spalding

Thomas and Elizabeth had substantial stables in Eastgate and lived in an imposing three-storey residence called Rutland House on Star Road. The then Earl Fitzwilliam was known to buy several hunting horses from their stable yard.

When Thomas died at the age of forty-five in 1895, his wife Elizabeth (aged forty) was left with eleven children to support. Elizabeth successfully retained control of the horse breeding and dealer's business and later married Joseph Burton (aged forty-four), who was their business manager. By all accounts Elizabeth was a very shrewd businesswoman, a keen politician, and a successful and charitable woman.

Both Elizabeth and Joseph were staunch liberal activists and Elizabeth ensured that they canvassed everyone that was eligible to vote in the Boongate (now Eastgate) area to return a Liberal MP to Peterborough and a Liberal local councillor for the ward. Elizabeth used to take beer out to the Irish navvies who worked on building the roads in Boongate. This was all part and parcel of ensuring that they were registered to vote and could support the Liberal Party.

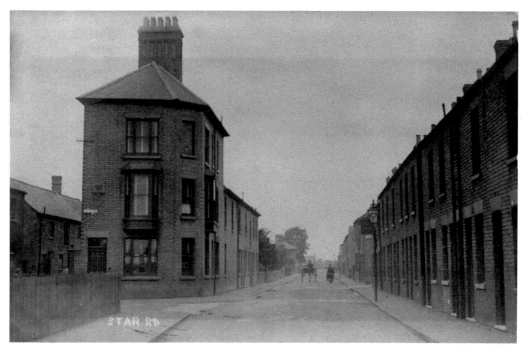

Thomas and Elizabeth Nutt's three-storey house in Star Road.

Nutt's stable yard, 1930s.

Sadly, Elizabeth was diagnosed with cancer in 1920 and eventually died two years later of pneumonia at the age of sixty-seven.

Thomas Nutt's third eldest son, also called Thomas, went to Brussels in 1900 and became a respected horse dealer, becoming a contact between Europe and the Nutt family in Peterborough and helping the Nutt family became a huge fraternity of renowned horse dealers. Tom apparently used to come over to the International Horse Show at Olympia, London, and ride there before the outbreak of the First World War.

Elizabeth's son also played a part in the 1912 George V Gold Cup at the International Horse Jumping Show, which was won by a horse called Murat and ridden by Lieutenant Delvoie of Belgium (who became the Belgian military attaché to Paris during the First World War). Tom was said to be either the horse's trainer or owner at that time.

The successful horse dealership ended in 1951, nearly eighty years on from when Thomas and Elizabeth started to build up an honest dealing business in Peterborough, then a small cathedral city and known throughout the Midlands as a town of 'pride, poverty, parsons and pubs'.

THE CITY'S MARKETS

The site of the original Market Hill covered the area from the cathedral (St Nicholas' Gateway) to the street west of the present St John's Square. That area (roughly where Queen Street is now) was known as Butcher's Row from the Middle Ages – all the butchers' stalls were grouped there. Interestingly, the Peterborough butchers claimed a sole right to graze forty-eight sheep on Flag Fen Common. When these open fields were enclosed they were given land in Boonfield (now part of Eastgate), known as Butcher's Piece, but subject to the local authority erecting some gallows for the execution of criminals.

The area today between Church Street and Exchange Street, plus the area from the cathedral gateway to what is now Queen Street, was called Market Stede – including the area north of St John's Church, which became Exchange Street after the Corn Exchange was opened in 1848. The Corn Exchange used to open on Saturdays from 12 noon to 3.30 p.m. for the sale of corn, potatoes and other agricultural commodities. At other times it was used for social events and auction sales. In June 1964 the Corn Exchange was demolished to make way for the Norwich Union building (demolished in November 2009), which is now occupied by St John's Square.

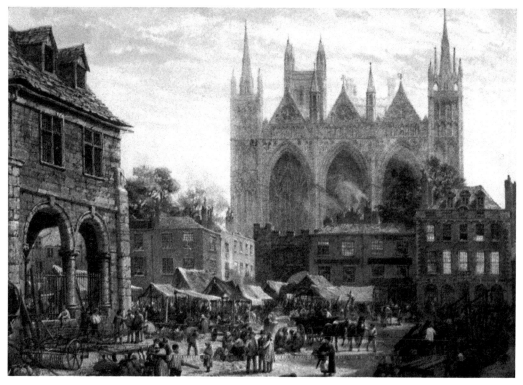

A thriving Market Place, c. 1864.

The whole area under the Guildhall was used as a poultry, eggs and butter market, and the area immediately outside St John the Baptist Church was used by fish sellers. Indeed, a water pump used to be located on the south east side of St John's to assist the fish stallholders.

Market Days in the Market Place (renamed Cathedral Square in 1963) took place on Wednesdays and Saturdays for the sale of general goods and produce. This market was relocated in 1962/63 to the area bounded by Northminster and accessed via Laxton Square, Cattle Market Road and Market Way.

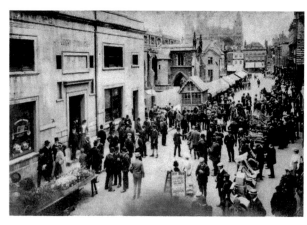

The Corn Exchange on market day.

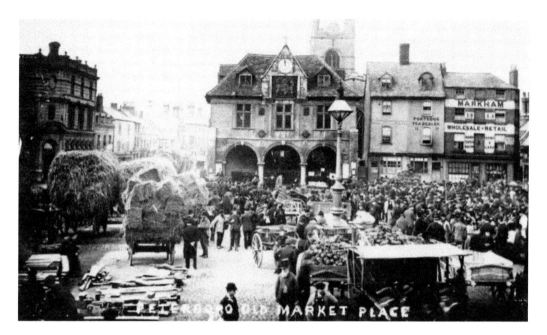

Above: A busy market day in the late Victorian period.

Right: Market day, 1895.

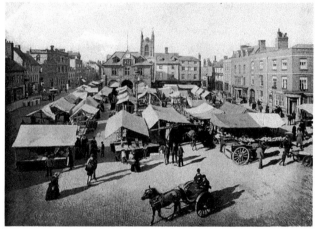

The old cattle market was created at a cost of £10,000 under an Act of Parliament in May 1863. It occupied 5 acres between Broadway and New Road (including part of a field called Simpsons Place) and opened in May 1867. It held up to 104 calves, 4,448 sheep and lambs, 520 pigs and 145 horses, together with a market house and sales offices. This market was well attended on Wednesday when it was a livestock market, and on Saturdays it sold every type of live and dead stock (including hens, ducks, rabbits, etc.). The cattle market was built with sheep and cattle pens, and a covered shed for pigs and calves. It closed in spring 1972.

Some notable market fairs included St Peter's, which was held in the city centre on the second Tuesday and Wednesday in July for the sale of wool, cattle and horses; and Bridge Fair, which took place on the first Tuesday, Wednesday and Thursday in October and was held in fields on the south side of the river to sell wool and general-purpose goods. There was also a skin market, held in Cumbergate, which was highly popular in 1713, but ceased at the turn of the twentieth century.

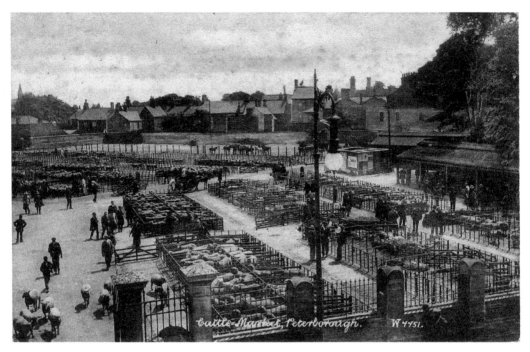

Cattle market.

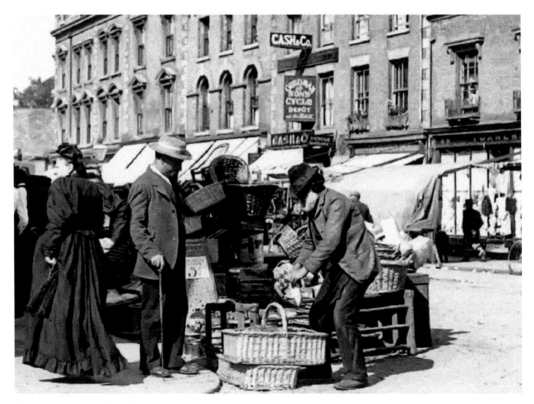

The basketmaker's stall.

GOING TO WORK IN WINDMILLS

Windmills first appeared in the UK from the late twelfth century. A fixed windmill structure would only work if the wind was blowing in the right direction, so the post mill, which could be turned into the wind, was favoured. These post mills were often sited on high ground or built on a raised mound to catch even more wind.

An obvious development by the end of the Middle Ages was the tower mill. The tower gave height and only a cap holding the sails revolved. Smock mills, which arrived by the late sixteenth century, are similar, but entirely timber-built compared to the tower type, which was built of durable brick or stone – hence more tower mills survive to the present day.

Windmills were particularly favoured in the windy flatlands of the Fens, with watermills in the upland areas with fast-running rivers and streams. Most villages had a mill to grind corn, but this power source could be turned to other uses such as tanning, paper making and gunpowder production. It is thought that the invention of mechanical fulling by water power was first introduced into this country by religious orders like the Cistercian monks.

The present Werrington tower mill, located at No. 1379 Lincoln Road, was built in *c.* 1864 but the base dates back to an older smock mill. This smock mill was on the site from the 1600s, but it subsequently burnt down in the 1830s.

Two of the present tower mill's sails were lost in the great storm of 1912, and the other two were removed in 1920.

Steam-powered production at Werrington Mill continued up to 1952 when corn miller Ernest Herbert Goff retired. He moved from Greenwich to Werrington in around 1902 and owned the mill until 1953. Werrington Mill continued as a warehouse, storing goods for local businesses, and in recent years it has been stripped of its outer tar layer. It is now fully restored as living accommodation, along with the former mill-house.

The *Northamptonshire and Peterborough Millers A–Z* booklet records Werrington Mill and its mill-house as being occupied and in working order in 1908, 1912, 1922 and 1953.

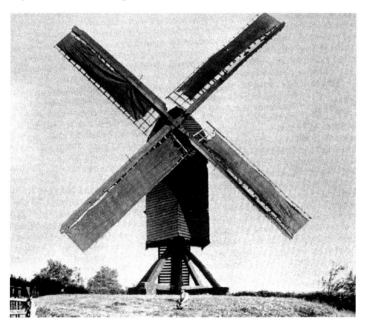

Fengate Post Mill.

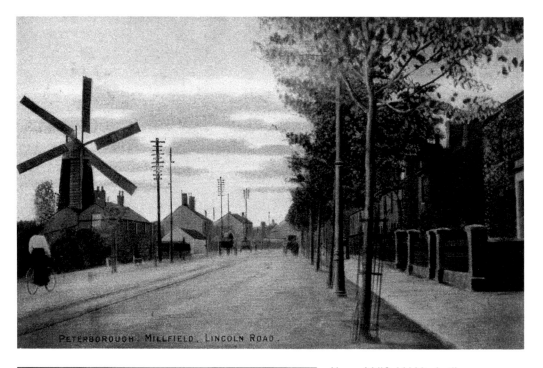

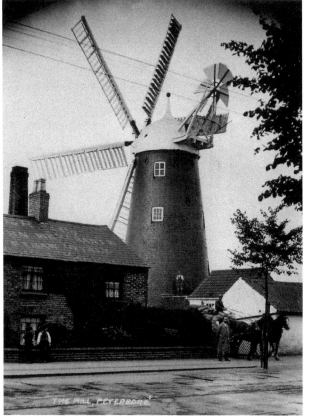

Above: Millfield Windmill, Lincoln Road.

Left: A closer view of Millfield Windmill.

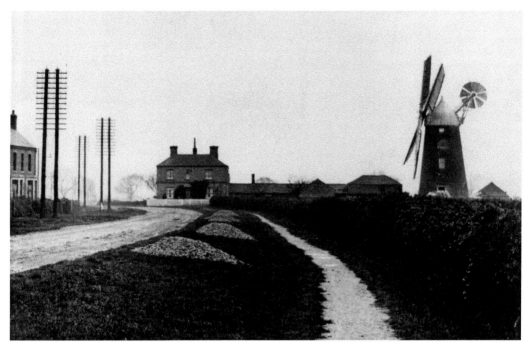

Werrington Windmill, Lincoln Road.

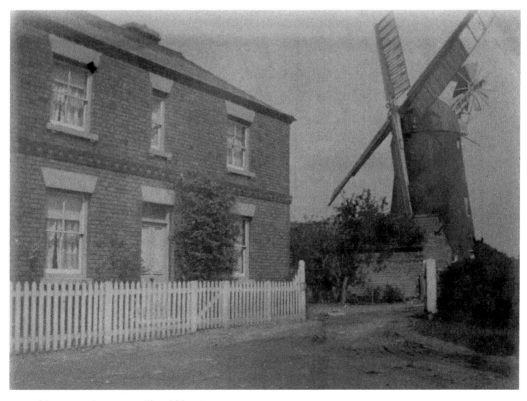

House and tower mill at Werrington.

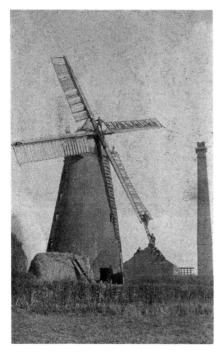

Tower mill at Orton Waterville.

Other notable mills in Peterborough include a tower mill at Millfield, once owned by John Adams and demolished in the late 1930s; Fengate Post Mill, which was owned by John Clark in 1806, James Holdich in 1809 and 1830, and William Holdich in 1854; New Fletton Tower Mill, erected in 1870 and demolished in 1974 (it stood behind The Peacock pub); and Castor Tower Mill, which nowadays has its stump remaining.

FIRE STATIONS AND FIREFIGHTING

Through the centuries Peterborough fireman have lived through traumatic experiences and, even at the time of the great fire recorded in the medieval documents chronicled by Hugh Candidus (a monk at Peterborough Abbey), firefighting was non-existent in any organised form, although the Romans and Egyptians had systems in place thousands of years ago.

For Peterborough, the first mention of firefighting equipment appears in the town bailiffs' accounts of 1613, which mentions the purchase of eighteen leather buckets from London to be hung in St John the Baptist Church, Church Street. Repair of the buckets and payment to three poor men for helping at a fire is recorded in 1646. Later an Act of Parliament made payment compulsory.

In 1667 insurance fire brigades came into being whereby each insurance company ran its own brigade in the larger cities, but in smaller communities like Peterborough local men were paid to look after each insurance company's interests. Each company would issue a fire mark with the company badge and the insurance number on the building. It was at this time that firefighting equipment became a little more sophisticated and pumps were introduced – each operated by two men – but often they had to be filled with water from leather buckets. Fire hooks (long poles with a chain and hook at the end) were introduced and used to pull the thatch from houses close to the fire to stop the flames from spreading.

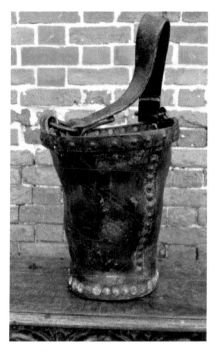

Above left: Leather fire bucket.

Above right: Insurance fire mark.

A 1707 Act of Parliament compelled churchwardens to ensure that in their parishes stopcocks and firecocks were fixed to all waterworks pipes, and a mark affixed to the front of any adjacent house to make their presence obvious. A notice had to be fixed in a prominent place giving a list of places where such cocks would be found. Each parish had to have a large engine, a hand engine and a leather pipe and socket to fit the plug or firecock. Those churchwardens who neglected these duties could be fined £10. In the early 1980s evidence of these parish engine stations could be found on church land at Alwalton, Eye and Werrington.

In 1707 Peterborough had only eighteen leather fire buckets. Messrs Merryweathers, fire engine manufacturers, took an order for a manual fire engine for Peterborough in 1823, and another in 1855 to supplement existing rudimentary equipment.

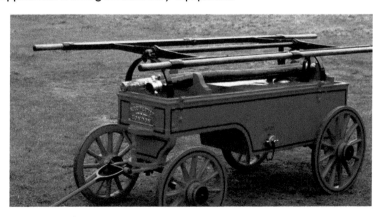

Portable fire engine.

In 1835 a fire broke out in Westgate and the Milton Street area due to a cottage having faulty brickwork in its chimney stack, which ignited the thatch. The fire spread rapidly to neighbouring properties; a total of 200 people were made homeless, two women died and there was property damage estimated at £3,000–£10,000. The fire engines stored at Cumbergate Fire Station, located on the north side of St John the Baptist Church (today the site where Miss Pear's Almshouse was built) attended, along with engines from Thorney, Whittlesey, Eye and Milton Hall.

In 1874 the Peterborough Improvement Commissioners were succeeded by the city council to run the fire brigade and so the Peterborough Fire Engine Establishment was formed.

On 8 May 1884 a fire took hold at the infirmary in Priestgate (now Peterborough Museum) where some twenty patients narrowly escaped from being burned alive. When the fire brigade arrived, it took 15 minutes to fit the hose to the pipe! The fire raged for 2 hours and thankfully the ground floor was saved intact – the rest was just a burnt-out shell.

The way the fire brigade dealt with this fire showed several weaknesses, and on 10 June 1884 the council held an inquiry into the brigade, its equipment, and function. The inquiry resulted in recommending that three additional fire stations be set up: one at Millfield, one at the Corporation Yard in St John's Street, and one at Fletton.

Another group of councillors, led by Councillor Clifton, decided to set up a volunteer fire brigade. The council agreed to this and Mr Gill was appointed as chief engineer and superintendent to both brigades. Peterborough's first volunteer fire station (1884) was in Brooks' Yard, Church Street, opposite St John the Baptist Church. The two brigades worked well together when a fire broke out at the rear of the Greyhound Pub and Hotel in Market Place that same year.

The city fire station remained in Cumbergate. In 1892 the council was urged to buy a steam fire engine.

Two large fires occurred in 1905: one on 27 June at Moy's railway-wagon works and the other on 16 October at the Baptist Chapel in Queen Street (the latter was reduced to rubble).

Peterborough's first Chief Fire Officer, Captain J. C. Gill.

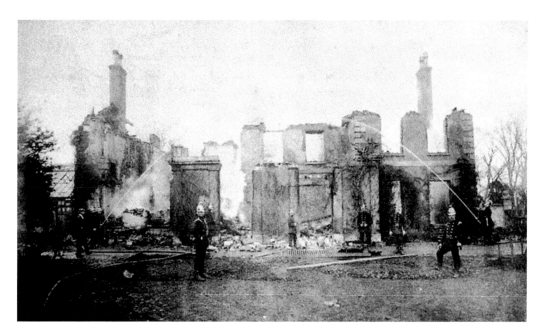

Above: Stanground Manor House fire, 1899.

Right: Moy's wagon works fire.

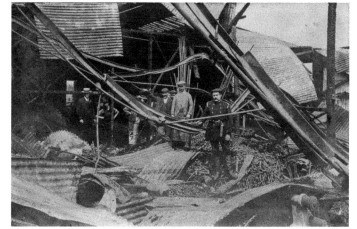

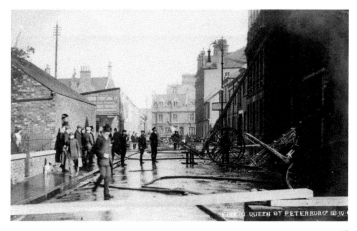

Fire in Queen Street.

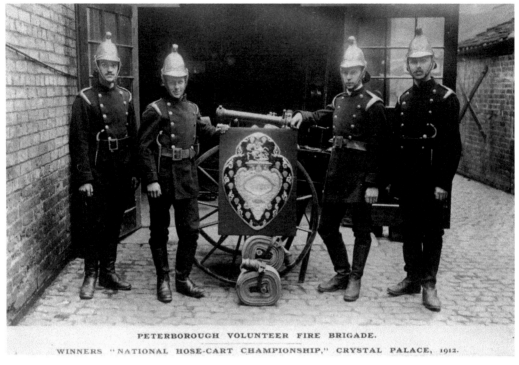

PETERBOROUGH VOLUNTEER FIRE BRIGADE.
WINNERS "NATIONAL HOSE-CART CHAMPIONSHIP," CRYSTAL PALACE, 1912.

Volunteer Brigade, Brooks Yard, Church Street, 1912.

In 1908 another steam fire engine was purchased. In 1912 the first mechanised fire engine was introduced when the volunteer fire brigade purchased a Model T Ford tender and in that same year went on to win the National Hose Cart Shield at Crystal Palace.

In 1915 Captain J. C. Gill of the City Brigade, who helped set up the Volunteer Brigade in its infancy, died on 29 July. At his funeral Peterborough city firemen and some Peterborough volunteer firemen, plus notable dignitaries, paid tribute to his life and works by expressing the fact that he was a faithful and true servant to the city.

Today, the Cambridgeshire Fire and Rescue workforce totals 393 firefighters (full time, part time and call out); with admin staff included, this figure rises to 577 in total.

THE TWENTIETH CENTURY

We have moved from a thriving market town to a railway city that has brought industrial grow and prosperity. The dawn of the twentieth century saw the city population boom.

We already had an infirmary in 1821 and in 1830 we gained gas street lighting and the Corn Exchange was built in 1846. St Peter's College was built in 1856 and our first public library opened in 1892. However, the best was yet to come as new industries appeared in the early twentieth century that would really put Peterborough on the map.

MILKING IT – HOW DAIRIES DELIVERED DAILY

Our city was blessed to have many dairy farmers and some of the better known are Horrell's and the Co-operative dairies.

In 1905, a young man named James Horrell could be seen in the city streets selling fresh milk to the general public from a small horse-drawn cart. On his first day he ladled out 60 pints into jugs offered up by housewives. The milk came from a herd of dairy shorthorns, and from that day on Horrell's became a household name. Their 11-acre site at Westwood

Horrell's badge.

Farm (now part of Netherton) grew to include a transport fleet of 100 vehicles, a modern dairy capable of processing 50,000 gallons of milk a week, and a staff of 140.

James Horrell, the founder, moved with his brother to the area and began farming at Westwood in 1896. Nine years later James started the milk round in order to sell his produce from his herd directly to the public, and over the next fifty years other milk retailers gradually sold out to him, giving Horrell's city-wide coverage. In the early years there were thirty-five horses drawing large four-wheeled milk floats, with the horses being attended to by a dedicated blacksmith with his own blacksmith's shop on the farm. Eventually the horses were replaced by motorised floats, with only Taffy the horse pulling his float under the direction of his driver, Mr Frank Hurst, remaining until 1972.

Left: Comic postcard on what the milkman got up to.

Below: Horrell's Dairies' fleet of horses and carts, *c*. 1954.

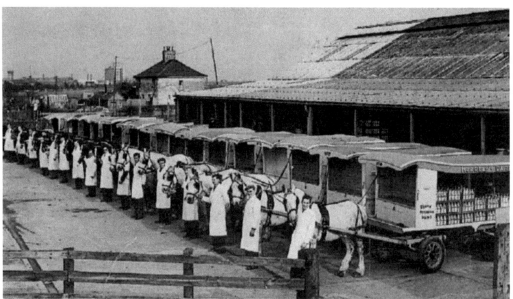

When James Horrell died his son Harry took over the business. In 1940 the heavy milk delivery churns were replaced by a very heavy milk bottle with a cardboard seal pressed into the broad top of the bottle. In 1955 the first electric float appeared in the familiar Horrell's blue and white colours. The latter was welcomed because they were quieter in the early mornings compared to the clomping of horse's hooves.

During the late 1940s/early 1950s tankers could be seen bringing milk to Westwood Farm from over forty farms far and wide.

In 1975 the founder's grandson, Mr Robert Horrell, celebrated seventy years of Horrell's Dairies in Peterborough. Robert also had agricultural interests at Elton and Bretton, with his herds making a significant contribution to the supply of milk for processing. This one company split into two in 1946 to become Horrell's Dairies Ltd and Horrell's Farms Ltd and comprised of four farms (the one at Westwood and three at Longthorpe) with a total of 250 dairy cows – two herds of pedigree British Friesians and one herd of Guernseys, which produced Channel Island and TT (Tuberculosis Typhoid) milk with a very high butter-fat content.

At the end of the Second World War the dairy was enlarged, and some years later it was re-equipped with a laboratory and became fully mechanised so that bottles were automatically extracted from the crates, washed, dried, filled, capped, and repacked into plastic crates holding twenty bottles.

Inspection by an electronic scanner would discard any bottle that was damaged or not 100 per cent clean. Bottles were never touched by hand during these processes, which ended when the crates were automatically stacked in the cold store, before the daily early morning doorstep delivery, seven days a week.

Horrell's Farms Ltd was dissolved in 1978 and Horrell's Dairies Ltd was taken over in 1990; it was formally dissolved as a limited company in 1993. Today the 11 acres of Westwood Farm pastureland comprises residential homes, but the actual dairy site is presently occupied by the New Covent Garden Soup Company.

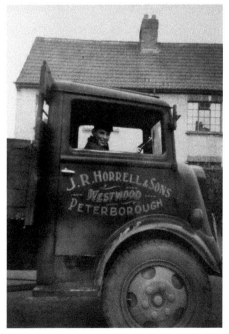

J. R. Horrell & Sons truck.

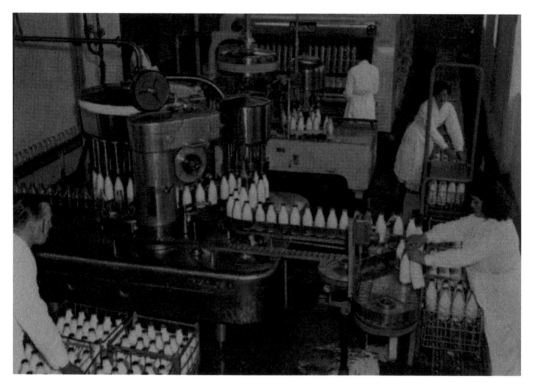

Horrell's bottling room, c. 1966.

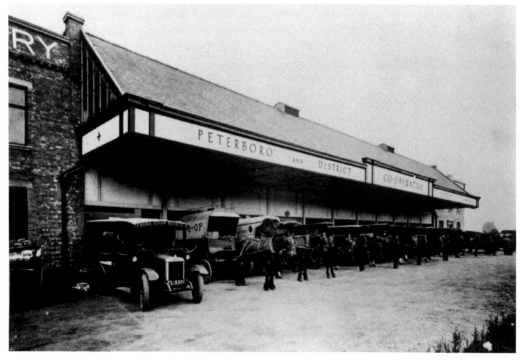

Co-operative bakery and dairy, Midland Road.

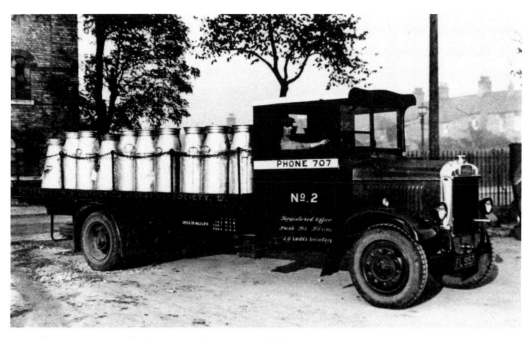

Co-operative milk churns on their way to delivery.

The other major milk producer and provider was the Peterborough Co-operative Dairy, located in Midland Road, on the same site as the Co-op bakery. The dairy used to be one of the most up to date in the country, employing 110 people. In 1939 over a million gallons of milk were taken in from 110 farms in Peterborough and its surrounding district. Cash sales in that year amounted to over £2.4 million. Nearly 2,000 gallons of milk was supplied to schools each week and milk powder for use in food products was made at the Co-op Dairy.

In 1940 there were 334 milk rounds served by electrical and petrol motors, horse-drawn vehicles and hand carts. The manager of the Co-op Milk Depot at this time was Mr J. Turner.

In July 2012 Peterborough City Council were seeking to buy the derelict factory site from a firm of administrators as it had become an eyesore. The appearance and safety of the buildings became an issue for residents of Midland Road. In April 2011 concerns were raised over the large amount of fly-tipped rubbish that was being dumped on the site, and in November 2010 fifty firefighters battled a blaze that tore through the dairy building. Earlier that year the adjacent bakery was also torched.

PETER BROTHERHOOD LTD, LINCOLN ROAD, WALTON

In 1906 the London works of Peter Brotherhood Ltd at Belvedere Road in Westminster outgrew its site and a survey of possible locations resulted in a decision by the board of directors to move to Peterborough – just 70 miles from London and with full railway facilities. A total of 100 acres of land was purchased at Walton, with 20 acres lying between the road to Lincoln and the main railway line. The other 80 acres, on the other side of the railway, remained agricultural, with some of the land later being used as Walton Golf Course.

Peter Brotherhood steam hammer.

Work on building the Peterborough site commenced in October 1906 and production started on 15 July 1907 without any loss to output. Early developments at the Peterborough works included the manufacture of compressors for the royal and merchant fleets, followed by orders for numerous steam turbines.

Among many items manufactured by the company's extensive works in Lincoln Road, apart from steam turbines, were diesel engines, marine auxiliaries, refrigerating and ice-making plant, and air and gas compressors.

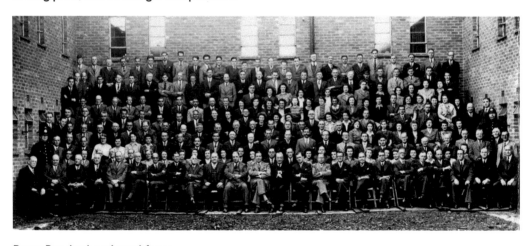

Peter Brotherhood workforce.

The pioneering work of the firm in the early days included the three-cylinder radial engine, which has always been associated with the name of Peter Brotherhood. The three-cylinder engine was first shown at the Vienna Exhibition of 1873 and achieved wide popularity thereafter.

This engine proved to be exceptionally well fitted for coupling to dynamos and centrifugal pumps for use in warships. In 1879 the company was supplying large consignments of electrical generating sets to warships, both British and foreign.

The specialisation in naval equipment made it possible for Brotherhood to play an active and valuable part in the war effort for both world wars.

During the First World War they substantially enlarged their works at Walton, with nearly 2,000 employed on munitions, battleship parts, cruisers, torpedo parts, gun parts, and tank engines. Their staff included naval men during the First World War. However, in peacetime between 600 and 1,000 were employed. Women also became part of the workforce when the men went off to fight in both world wars.

In 1902 Peter Brotherhood died and the business was taken over by his son, Stanley. Some three years later the Peter Brotherhood motor car – a 20/25-hp car – was manufactured. It was one of the early cars that travelled 9,000 miles without trouble and was designed by Percy Richardson, formerly of Daimler. The car was of a very advanced design and created considerable interest at the 1905 Motor Show at Olympia, London. It became known as the 'Brotherhood-Crocker'. One of the early directors of the company was Earl Fitzwilliam of Milton Hall. The Brotherhood-titled car continued until 1907, after which it became the 'Sheffield-Simplex'.

Brotherhood continued to be successful in the manufacture and sale of steam turbines, gas compressors, combined heating and power (CHP) systems and special purpose machinery

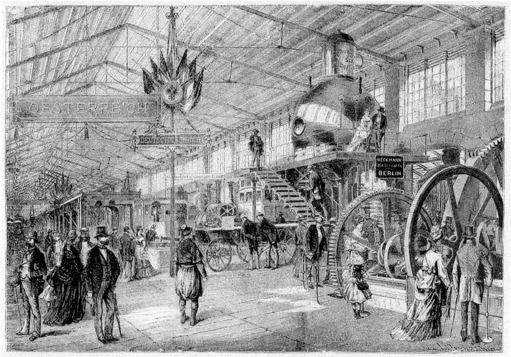

MACHINERY HALL AT THE VIENNA EXPOSITION.

Peter Brotherhood at Vienna Exposition.

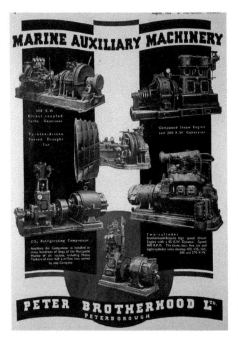

Left: Machinery at Peter Brotherhood.

Below: Female workforce during the Second World War.

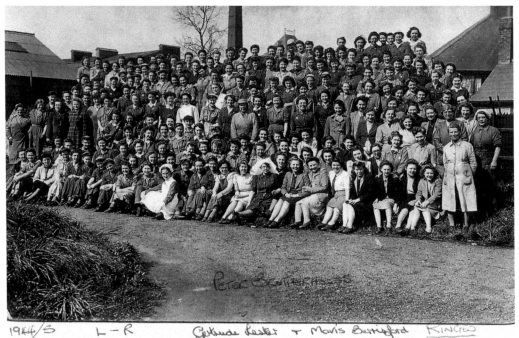

when the company celebrated 140 years of trading and 100 years in Peterborough in 2007. Its workforce held over 280 people in its centenary year.

Sadly, a year later, in June 2008, Brotherhood was bought out by an American company, Dresser-Rand, for £31 million, with the acquisition taking place on 1 July 2008. The Brotherhood site on Lincoln Road was demolished to make way for the existing

retail park. Dresser-Rand are located at their purpose-built premises in Papyrus Road, Werrington.

In November 2015 Dresser-Rand were bought out by Hayward Tyler and the name Peter Brotherhood was reinstated into the city's industrial heritage.

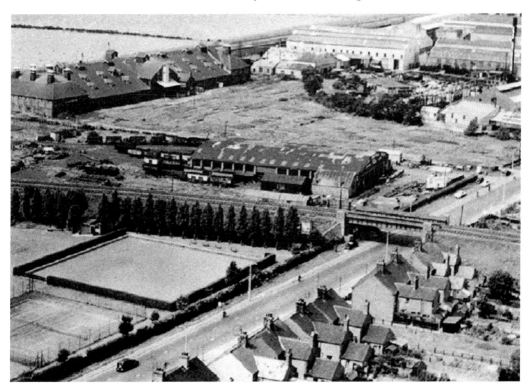

Above: Aerial view showing Peter Brotherhood at the top of the image.

Right: Peter Brotherhood's Duke of Gloucester visit in 2019, with General Manager Greg Harding in the background.

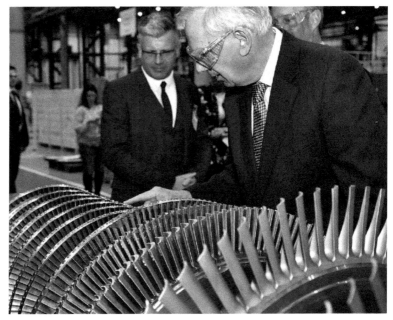

FARROW & CO.

This Lincolnshire company, established in 1840, moved to its Fletton Avenue factory in Peterborough in 1902. The site was located close to the Great Northern Railway and employed some 300 people.

Farrow peas and mustard were the main product line, although from the early Victorian period they were best known for the manufacture of mushroom ketchup, claiming to be the largest in the world in 1904.

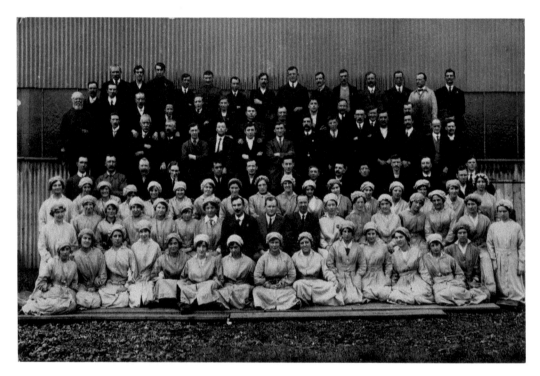

Above: Group photo of Farrow's pea factory workers.

Left: Advertisement postcard for Farrow's mushroom ketchup.

Much of its mustard seed was grown on its local farms, as was their peas. In 1912 the Peterborough factory was extended as exports, especially in dried peas to South Africa, kept the business booming. This same year Farrow & Co. acquired its leading competitors in mustard production – namely Barringer & Co., Moss Rimmington & Co., and Sadler's Mustard. At this time they introduced a 48-hour week for men and a 44-hour week for women.

In 1930 Farrow's entered into pea canning, and this became their main business until 1932 when the factory was extended to accommodate fruit canning as well as pea canning. Joseph Farrow Jr died in 1939 and his son, Joseph Algernon, took over the business.

In addition to fruit and peas the factory started to can other vegetables, and its staff doubled. By the end of the Second World War Farrow & Co. was one of the principal industrial concerns in the city – behind brickmaking and ranking alongside sugar beet processing.

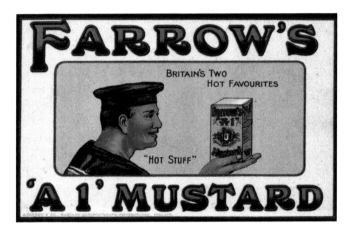

Right: Farrow's advertisement postcard.

Below: Farrow's factory, Fletton Avenue.

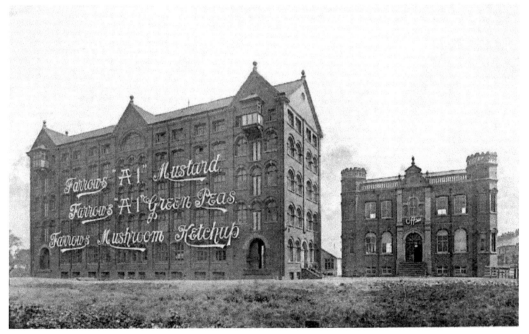

In 1948, R. W. Gale & Co. Ltd, London, a processor of honey, was acquired. Unfortunately, the growth period for canned foods had mostly ended by the early 1950s. The Farrow company was sold in 1971 to Batchelors of Sheffield (a Unilever subsidiary). Farrow's parent company, J&J Colman, continued to manufacture honey and preserves at its Peterborough factory until its closure in 1973, with the loss of 250 jobs. Its entire production was relocated to Norwich and Unilever sold Batchelors in 2001 to the Campbell Soup Co., and five years later Batchelors was sold to Premier Foods. In 2011 Premier sold the Farrow's brand to Princess Foods in Liverpool. To this day, Farrow's marrowfat peas are still sold in Britain.

BERNARD STOKELEY LTD

Local building firm Bernard Stokeley became a limited company in September 1955, but was in existence from 1945. In the 1960s they took on £1 million worth of contracts without disruption to any of its existing work. They were well known locally as *the* go-to contractors for all government departments and local authorities for building and civil engineering works.

On the industrial side, they built factory/service space, including the main Perkins Engines Ltd factory, subsequent extensions, a single-storey office block and five-storey office block, a restaurant and engineering complex at Eastfield. A new cabinet factory and offices, extensions, modification and maintenance to A. E. I. Hotpoint works at Morley Road/Celta Way in Woodston was undertaken by Bernard Stokeley Ltd. Also, they were contracted to build the drawing office, modifications to the factory, boiler house, cooling towers, roadway and drainage to Peter Brotherhood's Walton works; plus the main factory, offices, extensions, new apprentice school and all roadways for Newall Engineering Ltd at Fletton.

Bernard Stokeley Ltd won the contracts on many public buildings and works, including Peterborough Police Station, Bridge Street (site now occupied by Premier Inn); the Nurses' Home in Holdich Street (part of what was the building assets of Peterborough District Hospital, Midland Road); as well as the main sewerage, complete with pump works, to bring Castor into the city system.

Other notable public works that stand testament to Stokeley's workmanship involve the building of the later extensions of what is now Peterborough Regional College but was then Peterborough Technical College.

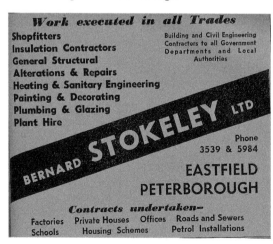

Stokeley advert.

Newall's factory, Shrewsbury Avenue.

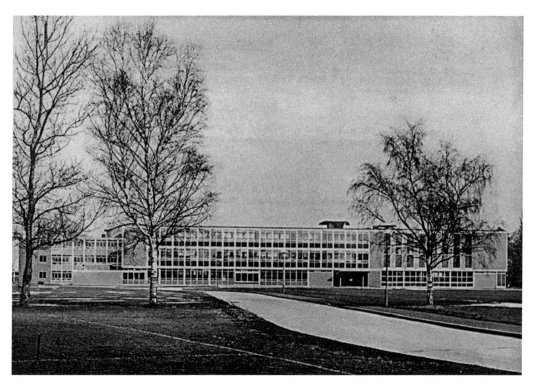

Peterborough Technical College, *c.* 1958.

From **W. S. READ**, BUILDER, ETC.,

66 PRINCES STREET, PETERBOROUGH.

194

W. S. Read's letterheaded postcard.

Stokeley also won contracts to build houses both in the public and private sectors, including 150 houses and all works for Peterborough Rural District – not forgetting the development of Stokeley's own office and yard at Rose Gardens, Eastfield.

Bernard Stokely Ltd was the main contractor for the present railway station buildings, as the old GNR booking hall and east side buildings were demolished in 1976 and replaced on an interim basis by Portacabins. The new buildings (which, with alterations, are those in use today) were opened in 1978 by the Minister for Transport, Peterborough's MP, Brian Mawhinney. These works were prior to the additional extensions and modification carried out in 2012.

Today, Bernard Stokeley Ltd has a registered office at No. 90 Lincoln Road. In February 2016 Josephine Mary Louth was named director of the company.

Throughout Peterborough's long history it has faced and accepted many challenges, including rapid growth – not from within but from outside pressures – and the city has always been willing to play its part in helping to solve the issues of additional housing, schools, factories, public buildings, etc., by providing new developments. New people, new thoughts, new industry, new cultural and recreational amenities assist with the city's expansion.

Local builders and the reservoir of resources in associated companies has been timely. Over many centuries our city's response to growth, individually and collectively, shows the capacities and capabilities of Peterborough's builders – from the largest to the smallest. It is hoped that in an expanding Peterborough its local builders will be permitted to play their full part.

RAF WESTWOOD

RAF Westwood opened in 1932 and served as a training base for Allied & Commonwealth pilots throughout the Second World War and early post-war years. Aircraft flown included Tutors, Harts, Audax, Fury, Demon, Battles, Moths, Oxfords, Masters, Ansons, Hurricanes and Harvards.

In 1948 the Ministry placed the airfield under 'civil care and maintenance' and for two years British Airways used it as a helicopter base for regular airmail services for East Anglia, with the General Post Office sorting the mail and parcels in aircraft hangars.

From 1958 to 1963 (the airfield closed in 1964), Baker Perkins, Mitchell Engineering and Mitchell Construction used part of the airfield to house their company aircraft.

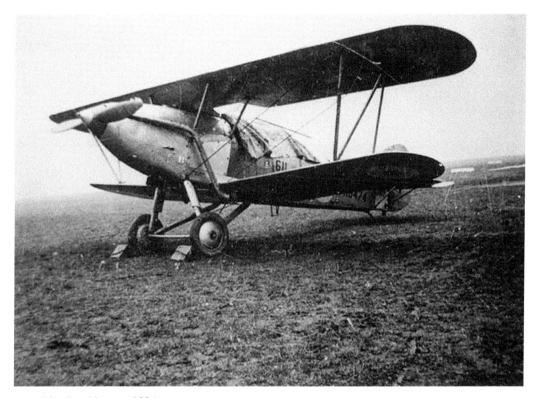

Hawker Hart, *c.* 1936.

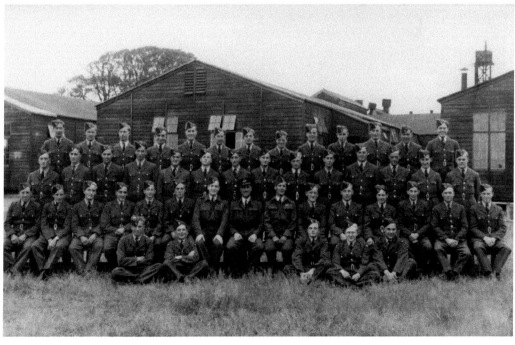

Group photo of RAF Westwood personnel.

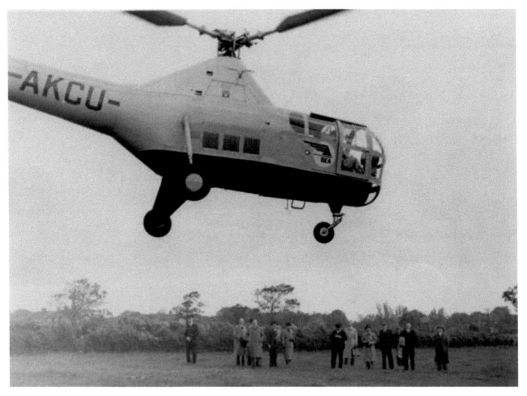

First airmail service from RAF Westwood.

The Station Office (No. 5) in Saville Road is one of only three remaining brick-built station buildings, and is unique as a distinctive and important military building. It is a two-storey dark-red-brick building under a slate roof. The main entrance has a pilastered door case. The sergeants' mess, also located in Saville Road, is a tall, single, dark-red-brick building with a slate roof. However, the jewel in the crown is the remaining junior officers' quarters and mess in Cottesmore Close. It is a commanding building in a formal and uniform style. The two-storey dark-red-brick building is under a slate roof with slightly projecting eaves. The main entrance comprises a white-painted stucco portico with four columns. The building is set within a driveway with railings defining the boundary.

It was the flat, open countryside around Peterborough that made it an ideal location for an airfield. However, the airbase was not without its fair share of flying accidents. The most significant was on 16 April 1936, when newly arrived twenty-year-old Air Cadet Harold Eric Smith-Langridge was killed along with the thirty-six-year-old pilot Flight Lieutenant Ernest Dawson in their dual-controlled Hawker Hart. Their aircraft was performing its second loop at 300 feet and suddenly it hit the ground, crashing into a hangar after flying in formation with two other aircraft. Two RAF personnel on the ground were also killed when struck by the aircraft, namely Percy Cuthbert and Stanley King (who died the following day). It seems the fire also destroyed an Avro Tutor and three Audax aeroplanes. The court of inquiry stated that the probable cause of the crash was due to the pilot, Flight Lieutenant Dawson, being drunk.

Another fatality was that of William Dycer Coppinger, who was killed in an air accident on 23 October 1936.

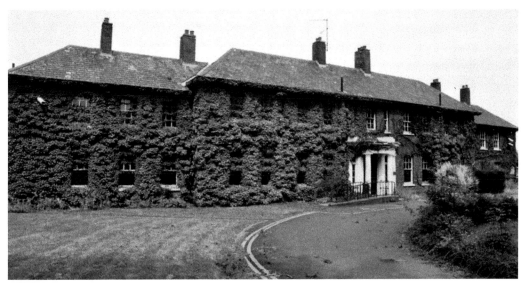

Junior officers' quarters and mess.

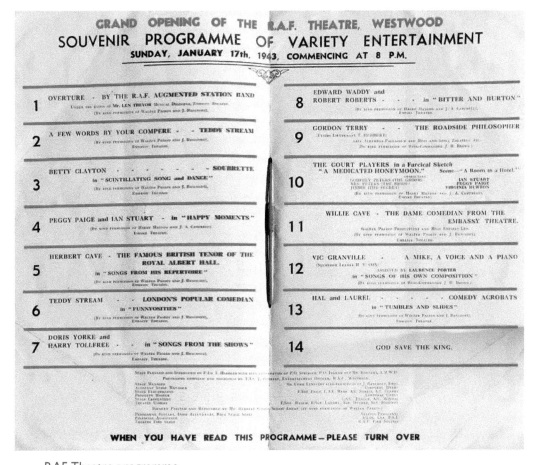

RAF Theatre programme.

From 1964 much of the airfield had residential homes built on it, and today most of the site is part of Netherton and Westwood housing estates. Nowadays, the junior officers' quarters and mess in Cottesmore Close is a training centre for Peterborough City Council staff. Presently, RAF Westwood is the home to Royal Air Force Cadet Squadron 115 Air Training Corp, in Saville Road. Their motto being 'to Aspire, Achieve and Excel in everything they do'.

WORKERS OF THEATRELAND

Work started on the Embassy Theatre, Broadway, on 26 January 1937. On Monday 1 November 1937 the Embassy officially opened to the public, with the owner Jack Bancroft receiving a multitude of cheers for all he had achieved in having this art deco theatre built in the city centre, which was the city's second-tallest building after the cathedral.

It was constructed of one million local Fletton bricks, had 196 windows, 250 doors, took 2,000 yards of Wilton carpet, and the lower foyer had underfloor heating under Italian marble tiles.

The Embassy Theatre was designed by the noted cinema architect David Evelyn Nye, with a seating capacity of 1,484, along with fourteen dressing rooms for artists. The architectural decoration, including plasterwork was undertaken by Mollo and Egan. The company that installed the lighting was FH Pride Ltd of Clapham.

Inside the auditorium there was one steep circle and stalls. The front circle offered excellent sightlines and was very close to the stage. The latter was nearly 9 meters deep and about 18 meters wide.

Mr H. Hall (formerly the personal touring manager of Gracie Fields) was appointed manager. Various artists, such as George Formby, Laurel and Hardy and Ivor Novello, appeared at the theatre.

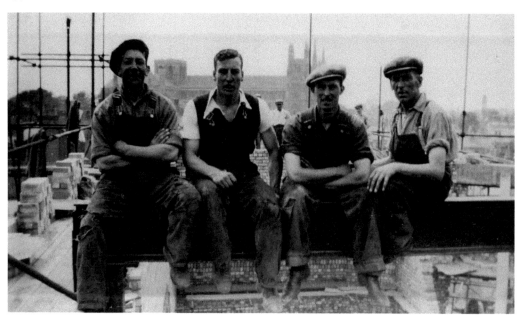

Construction workers on lunchbreak during the building of the Embassy Theatre.

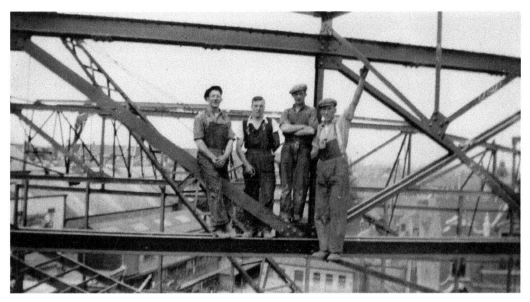

Workers pose for the camera.

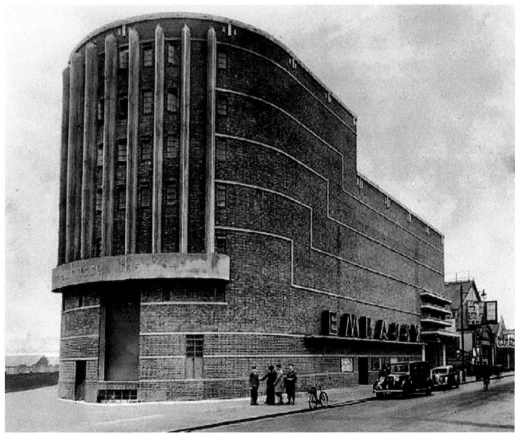

The newly completed Embassy Theatre.

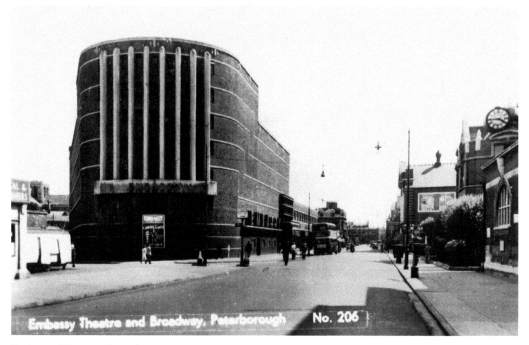

Embassy Theatre, Broadway.

In the early 1960s pop concerts were staged at the Embassy and live artists like The Beatles (who appeared twice – first on 2 December 1962 and then on 17 March 1963), Cliff Richard, Adam Faith, Frank Ifield, plus Tommy Roe, Chris Montez and many more, all played to local audiences.

The Bancroft Circuit owned and managed the theatre for nine years. In 1946 Peterborough Amusement Ltd took over the ownership and in 1965 the Associated British Cinemas acquired the Embassy but kept its name until it became the ABC. It closed as a single-screen cinema on 24 January 1981 and reopened as a triple cinema on 14 May 1981. A year or two after this the main cinema was again used as a stage. The ABC then became the Cannon Cinema, which in turn closed in 1989. The building and site entered a dark period until 1996 when the architects Mason Richards Partnership helped new owners to convert the building into a pub – The Academy.

Some of the films that helped make the Embassy a viable proposition included 1980s films such as *Superman 2*, *Ordinary People*, *Private Benjamin*, *Top Gun*, *ET* and *Beverley Hills Cop 2*. The latter two films substantially helped increase takings at the box office.

Today the Embassy is used as a plush nightspot – Edward's Bar – which holds karaoke nights and has a regular DJ, as well as plasma screens, a small dance floor, and seating for 1,000.

One Peterborian, 'Ernie' Percy Hills, fell totally in love with Tinseltown. He was born in Star Road on 22 August 1906 and educated at the City Road School, which has since been demolished. He officially left school at fourteen, but later admitted that he played truant from the age of thirteen because he was craftily going to cinemas to learn how to operate projectors – unbeknown to his parents.

Never to be outdone as far as money matters were concerned, Ernie had a lucrative sideline in buying and selling chickens, which lasted for decades. This occupation sat alongside his passion for cinema and theatre, and the chicken sales helped him build up a good nest egg.

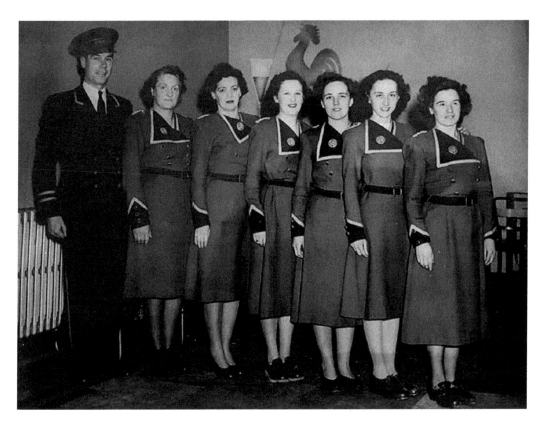

Above: Embassy ushers.

Right: Ernie Hills.

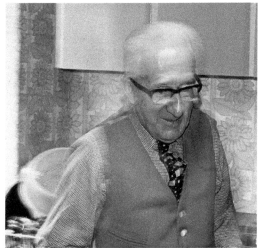

Ernie's fascination with the cinema meant that he was able to learn about all aspects of the film industry. He worked as a projectionist at various cinemas, both locally and around the country, to gather expertise. It was in the late 1930s that he worked as a stagehand at the Embassy Theatre, Broadway, to gain knowledge of the theatre industry. While working there he became a good friend of Jack Bancroft, owner of what was then the Embassy Theatre.

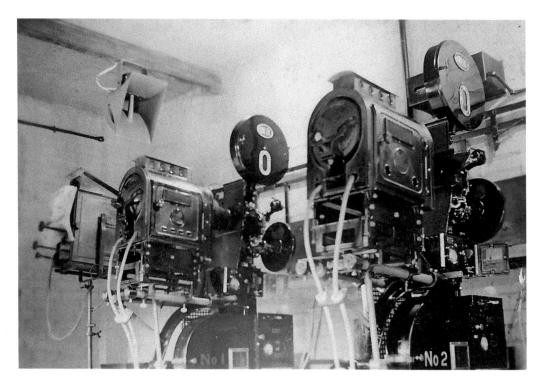

Above: Princess Cinema projection room.

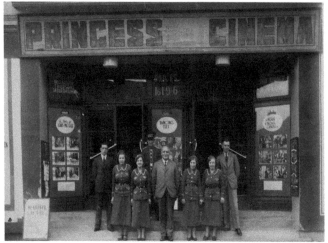

Left: Princess Cinema staff with manager Mr Ernie Hills (centre).

During the Second World War Ernie was a firefighter, and he later became the manager of the Princess Cinema in Lincoln Road, then the Savoy Cinema in Palmerston Road, Woodston. In February 1945 he got married, but was divorced a few years later.

Ever active, Ernie was a steward at Peterborough Cathedral for more than fifty years. After retirement he refused to give up his passion for cinema and theatre, so he became a voluntary usher at the Key Theatre, which kept him in touch with the nation's favourite actors.

He spent his final years at Park House Nursing Home, Park Crescent, where at the age of ninety-five he gave an hour-long talk entirely from memory to other residents about local cinemas and theatres.

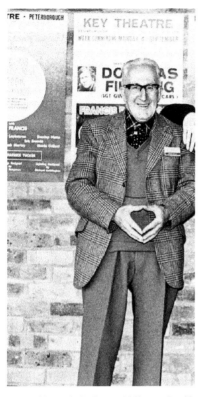

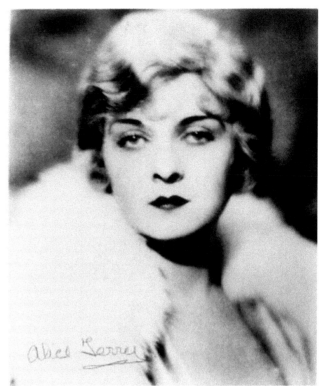

Above left: Ernie Hills at the Key Theatre.

Above right: Ernie Hills' favourite actor, Alice Terry.

Ernie confessed to believing that there were people behind the screen looking out through glass at the audience, and that occasionally he felt as though he could touch them, because it all seemed so real. His favourite films were from the early cowboy genre, especially those that featured Thomas 'Tom' Edwin Mix (film career 1910–35) or William S. Hart. These silent film Hollywood megastars paved the way for the cowboy actors who followed. Ernie also said that his all-time favourite female actor was Alice Terry (film career 1916–33) and that she was everyone's dream girl, so when she was in a film people had to tear him away from the screen. One of Alice Terry's most acclaimed performances came as Marguerite in *The Four Horsemen of the Apocalypse*, starring Rudolph Valentino as Julio.

Ernie died in Park House at the grand age of ninety-six in January 2003. To his credit he possessed an amazing memory and an incisive mind well into his nineties. Peterborough cinemagoers have a lot to thank him for, as he was one of Hollywood's best advocates.

MITCHELL ENGINEERING LTD

Bridge House, at the bridge south of the River Nene, was home to the offices of Mitchell Engineering Ltd, who also had works at Glebe Road and Fengate.

The company was founded in London in 1933 by Frederick (Fred) G. Mitchell (1885–1962) as the Mitchell Conveyor and Transporter Company. Fred, a completely self-made man,

was nicknamed 'Tiny' as he was 6 feet 4½ inches tall, with a bulk to match. He was born in London and at the age of fourteen he became an apprentice on the railway, serving his time in the engineering office at Nine Elms. He then graduated to the railway drawing office. After that, he found work as a draughtsman with a firm of consulting engineers, where he gained experience of various engineering jobs, including the Ritz Hotel, the Gaiety Theatre, and the designing of bridges (some in India).

His next career move was to the engineering firm Fraser and Chalmers, where he became head of the machine planning department, working on the design of machines to deal with any contingency in clearing and construction work. The latter created a civilian job for him during the First World War. He was attached to the French army to try to stem the retreat to the Marne with his trench-digging machinery. Then he was transferred to Kitchener's staff in Paris where he became a 'trouble shooter' for Kitchener.

When the First World War was over, at the age of thirty-three he took the rash step of setting up on his own. He started without a penny and won a contract to build a coal handling plant at a Birmingham power station, making him £40,000. The success of this project led to other power station contracts.

Some fourteen years later David Mitchell took over management of the business, and success led to more success when in 1962 Mitchell's acquired Kinnear Moodie – a leading tunnelling business. The range of products included boilers, mechanical handling plant, overhead transmission lines, ropeways, food preparation machinery, mechanical car parks and galvanising.

Mitchell was the chief company of a group whose activities included the design of atomic power plants to the manufacture of pea shelling machines. Mitchell exported its mechanical handling equipment and boilers – and these are found in many power stations in many parts of the world – plus other big engineering projects such as harbours, ore plants and power schemes.

Frederick G. Mitchell, aged sixty-four.

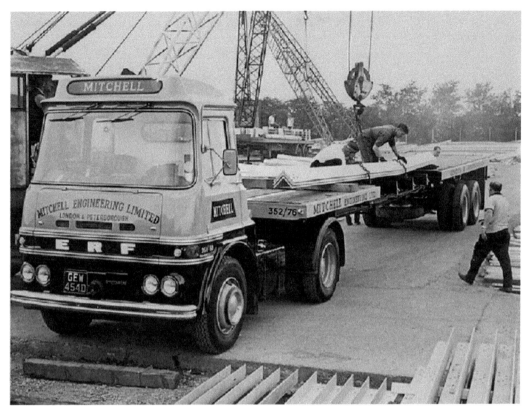

Mitchell Engineering lorry unloading.

Mitchell coal handling plant, Shanghai, China.

The company extended its interest in nuclear power when it made an agreement with AMF Atomics Incorporation of New York to design and construct atomic power plants in most parts of the world.

Another important side of Mitchell's activities was civil construction work carried out by Mitchell Construction Company Ltd. Its headquarters were at Bridge House,

Building site of the new Mitchell Construction offices, Bridge House.

Peterborough – architect Howard V. Loss & Partners. It constructed the atomic power station at Chapel Cross, near Annan, in Dumfriesshire (now decommissioned) and erected dams for the north of Scotland's hydro-electric scheme.

Mitchell Ropeways Ltd was another associate company headquartered at Peterborough.

Two years before Tiny's death he financed Rotocraft, a business that developed the grasshopper helicopter in partnership with its designer, J. S. Shapiro.

Sadly, in 1973 Mitchell Construction Ltd (Peterborough) became defunct under its managing director, David Morrell, after getting into financial difficulties over the Kariba Dam North Cavern project. The company was acquired by Tarmac and integrated into Tarmac Construction in 1973.

At its peak the company employed 5,000 staff, turning over £500 million in today's terms, and at one time simultaneously held the world records for hard and soft rock tunnelling.

It's office at Bridge House, overlooking the Nene at Town Bridge, was demolished in 2012 and with it went two unique works of art – the Ayres bas relief and the Vergette tiled mural. The former covered the entire frontage of the main block on the Town Bridge frontage.

Bridge House was designed and built in 1955 in a modern Scandinavian style. An unusual feature, apart from the mural sculpture designed by Arthur J. Ayres (carved in situ on fifty-one Portland stone panels) that depicts mythical and historical figures from science and engineering, was the drawing office with massive windows overlooking the river. The reflective, metal, wave-shaped ceiling panels designed to diffuse light uniformly made for an excellent drawing office.

The Vergette tiled mural, which was in the reception of Bridge House, was made of 140 glazed tiles and depicts typically industrial shapes. This tiled mural is the only substantially surviving mural by Nicholas Vergette (born in 1923 at Market Deeping). In 1958 Vergette accepted a visiting professorship at the School for American Craftsmen at Rochester Institute of Technology in New York State.

Today the Ayres bas relief mural can be found near the multistorey car park at Fletton Quays and the Vergette tile mural has been restored and is in a meeting room at the Allia Future Business Centre at the Motorpoint Stand of Peterborough United Football Club.

Mitchell drawing office.

Above left: Mural of Sir Isaac Newton, Mitchell Construction.

Above right: Mural of Arthur Rowledge, Mitchell Construction.

Above left: Mural of Bishop Robert Grosseteste, Mitchell Construction.

Above right: Tiled mural by Nicholas Vergette, Mitchell Construction.

GETTING ON OUR BIKES – PEDAL-CRAZY PETERBOROUGH

Cycling has a long and proud history in Peterborough. Not only was the bicycle used for getting to work, but also for leisure and sport. The Peterborough Bicycle Club was formed in 1874, although evidence has come to light that it could have been formed in the previous year. The aim was to 'unite bicyclists in the city and neighbourhood, to set up races, to provide prizes and arrange excursions'. The club colours were blue and gold, but not on Sundays. Founding members of the Peterborough Bicycle Club were G. L. Julyan, J. T. Miller, C. Foote, A. M. Pentney, W. H. Pentney and J. Mullet.

One of the best-known bicycle suppliers is Pell and Parker Ltd, who have been supplying the cycle trade for well over 100 years and are still going strong. Interestingly, Pell and Parker produced a motorcycle in 1914, appropriately named Pello, that had an arno engine. The company had their premises at the junction of Westgate and Cromwell Road. The company is still trading today, but as Richardson's Cycles, with stores in Queensgate (Peterborough), Stamford, Huntingdon, St Ives, King's Lynn and Corby.

The cycleway system in Peterborough won national and international acclaim in 1992 because it offered speedy and safe travel for those fit enough to leave the car at home. In fact, our city was singled out as one of the top ten in the country when it came to looking after cyclists.

In the early 1990s a national survey was designed that covered over twenty topics, including special facilities, catering for leisure cycling, cycle parking, cycle pathways, etc., and

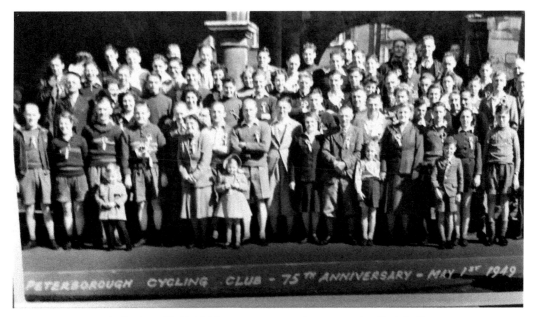

Peterborough Cycling Club's 75th anniversary gathering at the Guildhall.

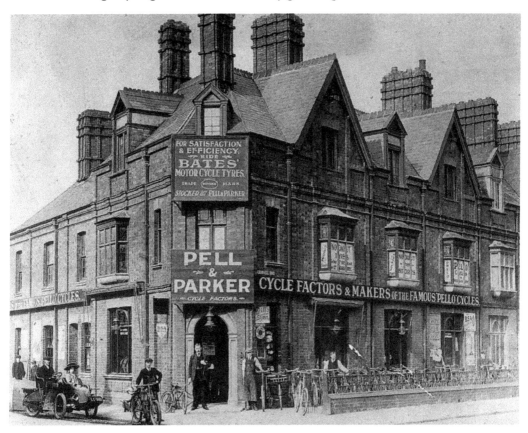

Pell & Parker, corner of Westgate and Cromwell Road junction.

A very neat combination. Power plant of the 3½ h.p. m.o.i.v. Arno, showing disposition of carburetter, magneto, and footboard.

Left: 3.5-hp Arno engine, Pell & Parker.

Below: Lady with her Pell & Parker motorbike.

the result was that Peterborough proved to be top of the pile, while places like Liverpool were dubbed disaster cities for cyclists.

In 1977 the first experimental cycle route in the city was launched as part of the new town development that linked the city centre with Westwood and Bretton. Following that success, a whole web of cycle routes followed, covering a total of 90 miles. At this time the routes were considered so good that nearly one in six people travelled to work by bike every day – above the national average. Thus, cycleways were deemed an integral part of the master plan of all the new townships, which were modelled around two-wheeled enthusiasts as the parkway system catered for motorised transport.

However, it was not all plain sailing, as when planners decided to put cycleways through the middle of the city centre traders became very concerned about loss of business. Traffic lights were put in place to give cyclists the right of way over motorists, and when Bridge Street was pedestrianised cyclists created havoc among people thinking they were safe walking along with their children or the elderly thinking they had the right of way at a steady pace.

Sadly, when Bretton Centre was ready for opening, some cyclists used it as a 'racetrack', and the introduction of underpasses meant both cyclists and pedestrians became very concerned as they became ideal gathering places for groups of youths. Additionally, developers who introduced cycle-only paths on the side of the roads had not predicted that motorists would tend to ignore the cyclists and ultimately people got injured.

Above left: Railway cycleway.

Above right: Cycle map.

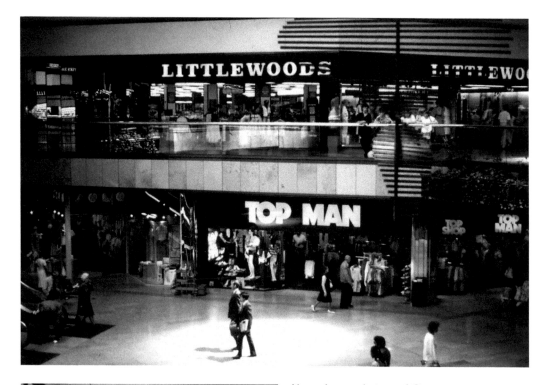

Above: Internal view of Queensgate shopping centre.

Left: Reflections café, Queensgate.

Queensgate's escalator to the first-floor shops.

Indeed, when Queensgate was opened in 1982, cyclists found they had nowhere to park their bikes, so not all the plans to extend and improve the city's cycleways and facilities had been thoroughly thought through by the City Council Planning Department or Peterborough Development Corporation. Eventually, the authorities did succeed in signposting the safest cycle routes through the city centre and between the new townships.

In 1992 Brian Mawhinney (one of the city's two MPs) said: 'He was delighted with the city's recognition of being one of the top 10 rated for looking after cyclists. Indeed, he went further by stating that the city maintains the cycleways to the highest standards because it is essential that the use of cycles is encouraged – especially when people are concerned about the environment.' This stance has not diminished over time.

THE HISTORY OF OUR HOSPITALS

The foundation stone to the War Memorial Hospital, at the corner of Midland Road and Thorpe Road, was laid on 25 July 1925. The previous building on the site was Thorpe Lawn, a private house that then became the first meeting place of the British Legion. The site was generously given to the people of Peterborough by Alderman Bunting of Spalding (former Peterborough resident and freeman of the city of Peterborough).

The Memorial Hospital cost between £70,000 and £80,000 to build and was established as a voluntary hospital from public contributions made after the First World War. It was officially opened on 14 June 1928 by Field Marshal Sir William Robertson, with over 160 beds, as a memorial to the dead (over 1,000 local people) of the First World War. The children's hospital to the south included an open ground and first floor sun parlour, and was officially opened in 1929.

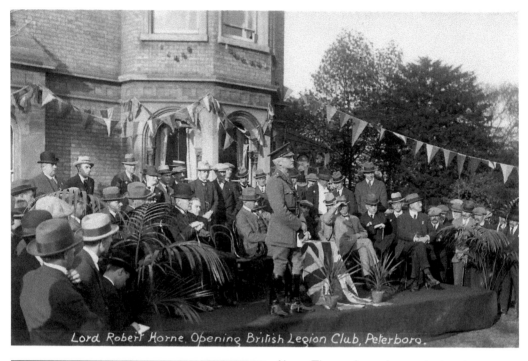

Lord Robert Horne, Opening British Legion Club, Peterboro.

Entrance, New War Memorial Hospital, Peterborough

Above: Thorpe Lawn house during the opening of the British Legion Club.

Left: New Memorial Hospital entrance, Midland Road.

Hospital at Priestgate, which became the city's museum and art gallery.

Prior to this the city's hospital was housed in Priestgate – the present museum building. It was here until 1928 when patients and equipment were moved to the new purpose-built Memorial Hospital in Midland Road with its classical portico entrance.

By 1940 the Peterborough War Memorial Hospital was recognised as a training school for nurses under the General Nursing Council and there were additions of an outpatient department, a massage department and a new boiler house and heating plant. At this time the nurses' homes were located at Midland Road and Sutton House, Aldermans Drive.

The War Memorial Hospital was transferred to the National Health Service in 1948, coming under the Peterborough and Stamford Hospitals Management Committee of the East Anglian Regional Hospitals Board.

The hospital was enlarged by the massive addition of Peterborough District Hospital, which was built in continuous phases from 1960 to 1968 and provided 400 beds.

The 153-bed Edith Cavell Hospital in Westwood was officially opened in 1988 and coexisted with the District Hospital to complement its services. Initial plans allowed for the extension of Edith Cavell Hospital, but it closed in November 2010 to make way for one super-sized hospital – the City Hospital. Today, the site of Edith Cavell Hospital forms part of Peterborough City Hospital's car park.

The City Hospital is a 635-bed, four-storey building in Bretton Gate and replaced facilities at both Edith Cavell and the District hospitals. The City Hospital is the largest building project seen in the city since the cathedral was built over 900 years ago, and marks the final piece in the jigsaw that forms the £335 million Greater Peterborough Health Investment Plan.

The City Hospital in Bretton Gate opened in the winter of 2010, and the former District Hospital and War Memorial Hospital site is now a mix of family houses, apartments and home to West Town Primary Academy. Today, nearly 6,500 people work at Peterborough City Hospital NHS Trust.

Peterborough Memorial Hospital and District Hospital at the junction of Thorpe Road and Midland Road.

Edith Cavell Hospital.

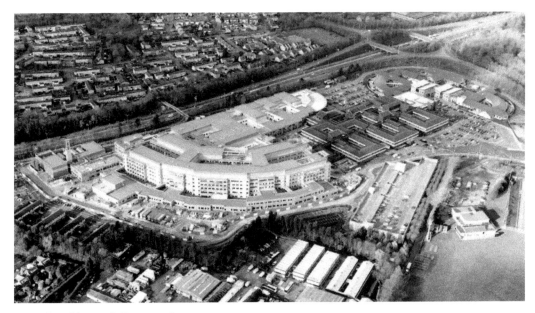

City Hospital, Bretton Gate.

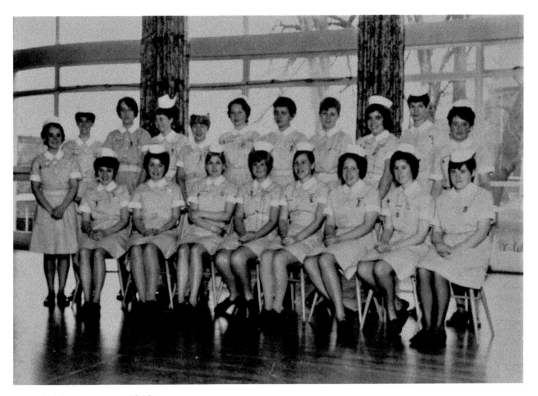

Trainee nurses, 1960s.

LOOKING AHEAD

Peterborough is a unique blend of old and new – the only cathedral city to be designated a new town back in the 1960s. As a result, it has become one of the UK's fastest growing cities, at one point the top fastest growing city in the country. Its population in the 1970s was 86,000 and it was 150,000 in the late 1980s. New figures released by the Office of National Statistics show that its population growth has been more than a quarter since 2001. Presently, it is the fifteenth fastest growing city, with a population growth of 28.5 per cent since a decade ago.

In the latter half of the twentieth century Peterborough was a natural choice for rapid growth – a city with a prosperous industrial base, particularly in engineering. It is well

Cathedral Square, Peterborough P.1104

Cathedral Square, formerly Market Place, c. 1975.

Having a glorious time here.

Why don't you pack your bag and come to Peterborough.

12 VIEWS INSIDE.

Comic postcard enticing people to come to Peterborough.

placed geographically, being on the main road and having rail links between London, the north of England and Scotland, and being midway between the major industrial cities in the Midlands and the increasingly important East Coast ports.

For centuries, Peterborough was a small market town dominated by its large Norman cathedral, but a welcoming town as it was home to the world's first refugees – the Huguenots, Protestant exiles from France during the late 1660s and early 1700s. Since then we have continued to welcome refugees, asylum seekers, economic migrants, Europeans and others.

Both economic and population growth started to change markedly with the coming of the railways in the 1850s, and the city grew into an important brickmaking and engineering centre. Expansion continued steadily until the late 1960s when a government programme was embarked upon to almost double the city's size. At that time much of the city's prosperity was based on engineering, with its companies doing exceptionally well in overseas markets. The city's manufacturing industry exported twice the rate achieved by Japan in the 1960s and 1970s. At the forefront of this effort were Perkins Engines, Baker Perkins, Peter Brotherhood, Newalls, and Mitchell Engineering, as well as a host of medium- and small-sized engineering firms.

The city's planned expansion programme sought to build on and expand this successful base, but to also increase the variety of employment available to local people and newcomers.

The Development Corporation, a government agency carrying out the expansion in partnership with the city and county councils, provided ready to occupy factories and a wide variety of sites on which companies could build their own premises. By 1983 several hundred firms had come to the city and around 400 new factories and warehouses had been completed on Peterborough Development Corporation sites. Completely new industrial

Left: Late
nineteenth-century
map, which shows
Peterborough in
Northamptonshire.

Below: Newall
Engineering's first
location at Old
Fletton.

Above left: Newall's jig borers advert.

Above right: Peterborough Motors – a Claas agent.

Right: Peterborough on the map.

areas were created at Bretton, Orton Southgate and Werrington, plus north Westwood, Eastfield and Woodston had been extended.

New firms included tobacco makers Molins, furniture makers Panel Plus, drink machine manufacturers Sodastream, Crosfield Electronics, Acco (office equipment makers), cold storage specialist Christian Salvesen, Pedigree Petfoods, Peter Pan Playthings, and health, beauty and care brand manufacturer Potter and Moore (renamed Jean Sorelle Ltd) and subsequently taken over by Creightons PLC.

Apart from attracting new firms the Development Corporation established a park for high-technology firms at Lynch Wood on the southern edge of Ferry Meadows Country Park.

In addition, the city is close enough to the rich farmland of the Fens to have an established foothold in the world of agriculture. At Alwalton there is the East of England Showground, which attracts prestigious annual events.

Apart from the Fens providing rich fertile soil on which to grow various fruits and vegetables, the low-lying land used to be used for social occasions as this greetings card from one of the city's largest engineering works depicts.

Left: Baker Perkins Christmas greeting card with a skating match in the Fens.

Below: Molins factory.

Right: Potter & Moore box of soaps.

Below: Part of a Crosfield Electronics Ltd-manufactured computerised machine for the graphic art and pre-press industry.

Higher education also plays a part in the city's skills base to attract the right businesses to match our workforce. Peterborough Regional College University Centre, Park Crescent campus, delivers a range of higher education courses in engineering and construction that are accredited by Pearson EdExcel. In addition to this Peterborough Regional College also provides a range of level 4 qualifications in professional and teaching-related subjects.

University Centre Peterborough (UCP) was established in 2007 and was previously a joint venture between Anglia Ruskin University (Cambridge) and Peterborough College. From 1 August 2020 it became a wholly owned subsidiary of the Inspire

Lynch Wood business park.

A postcard of Peterborough, 'Gateway to the Fens'.

East entrance to the East of England Showground at Alwalton.

PRC University Centre.

Education Group. UCP is an approved partner of Anglia Ruskin University, who accredits some of the undergraduate degree courses approved by the Open University, leading to Open University-validated awards at both Peterborough and Stamford campuses.

In September 2022 Anglia Ruskin University Peterborough, Embankment campus, is opening, which will provide transformational and inclusive higher education at levels 5 and 6 for the city and region.

Construction work started in 2021 on Peterborough's new university, which will work with employers as co-creators in developing and delivering the curriculum, which will be led by student and employer demand.

University courses in Peterborough will be delivered through a mixture of campus lessons, in-work training and apprenticeships, with distance learning and outreach programmes to improve accessibility and widen participation.

The new university will open to its first 2,000 students in autumn 2022. It's research and development centre is planned to open in summer 2023 and will feature nearly 3,500 square meters of flexible research space over three floors. It is a joint venture between Cambridgeshire and Peterborough Combined Authority and Peterborough-based business Photocentric.

ARU Peterborough sign.

ARU Peterborough development site.

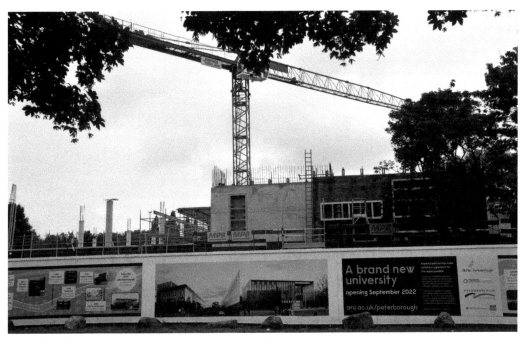

ARU Peterborough – construction well underway.

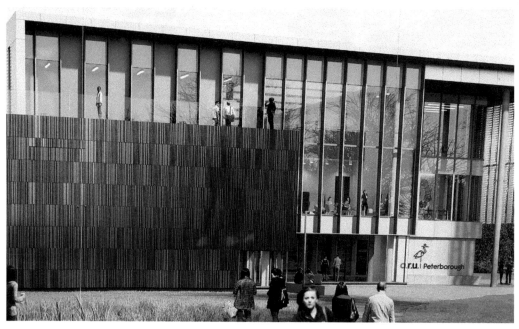

ARU public display board showing an artist's impression.

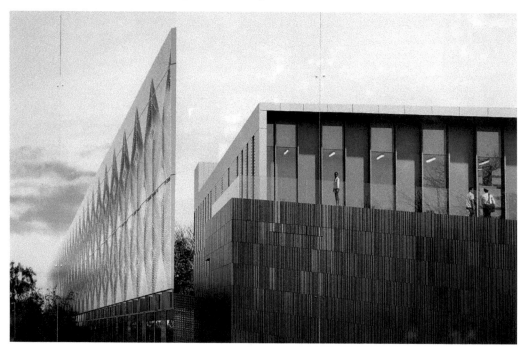

ARU public display board showing architectural features.

The research and development centre will link with local industry to foster collaboration and innovation in a wide range of materials technologies, including 3D printing research, sustainable plastics and new ways to make batteries.

Another boost to the city in terms of attracting business, leisure and homes is Fletton Quays development, which commenced in 2017 and is intended to help the city to thrive. The site is nearly 6.5 hectacres of prime riverfront development land south of the city centre between the River Nene and the Peterborough to March railway line.

The site was previously derelict land and vacant buildings. It is now a short walk to the city's main commercial, shopping and recreational areas. The Key Theatre and the Embankment are just across the river.

Fletton Quays includes 350 quality riverside apartments, office space, cycling and pedestrian links along the south bank, new public spaces offering views across the river towards the cathedral, a dedicated wildlife area, plus the refurbishment of Grade II listed Victorian rail sheds. Additionally, the scheme will be the location of a 160-bed hotel by the Hilton Garden Inn brand, home to a restaurant, retail and leisure opportunities plus the creation of hundreds of jobs. A major part of the site's development is the renovation of one of the Garde II listed Victorian rail sheds into Peterborough City Council's new office – Sand Martin House.

The city's various expansions have always sought to complement and enhance the historic fabric of the city. For example, taking Queensgate as a well-established shopping centre and revitalising it with new stores, shops and entertainment; building on a strong industrial base with further new industry, warehouses and offices; vastly increasing the number of jobs and widening the choice of careers; with schools; health facilities, improved leisure and recreation, new roads and parks, as well as thousands of new homes. Progress has been rapid for this city on the Fen edge, taking it to a prosperous and exciting future.

Peterborough has come a long way in terms of its growth since American novelist and short story writer Nathaniel Hawthorne visited our city during his tour of England

New apartments at Fletton Quays.

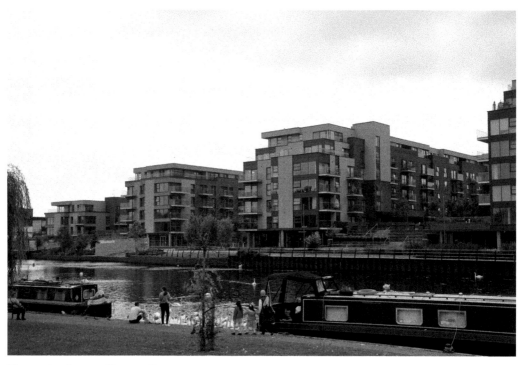

The embankment, Fletton Quays.

New hotel under construction at Fletton Quays.

Above: Sand Martin House,
Fletton Quays.

Right: Nathaniel Hawthorne
carte de visite, c. 1860.

between 1856 and 1857 when he wrote: '…of all the church closes that I have beheld, that of Peterborough Cathedral is to me the most delightful; so quiet it is, so solemnly and nobly cheerful, so presided over by the stately Minster, and surrounded by ancient and comely habitations of Christian men'.

ACKNOWLEDGEMENTS

This book does not attempt to include all the industries that made this city great. Indeed, some of the major ones are nationally and internationally known and have been comprehensively covered elsewhere over the years.

In researching and speaking to various industry workforce members and business people over the decades we are especially indebted to Kathleen Church; Vera Seeley; Marina Jones; the late Harry Miles and his recently deceased daughter, Jean Miles; the late Jack Gaunt and John Seeley; the late John and Jo Gillatt; the late Brian and Mary Rainey; the late Victor Casbon; the late Peter Boizot; and Pauline and Ken Firman. We are also grateful to fellow local historians Neil Mitchell, Rita McKenzie, Peter Waszak, Peter Clarkson, Brian White and Stephen Perry, who have over the years helped us piece together the wealth of enterprises that have made this city what it is today.